First Projects

A Pictorial Introduction to Woodcarving

for Woodcarvers

Larry Green & Mike Altman

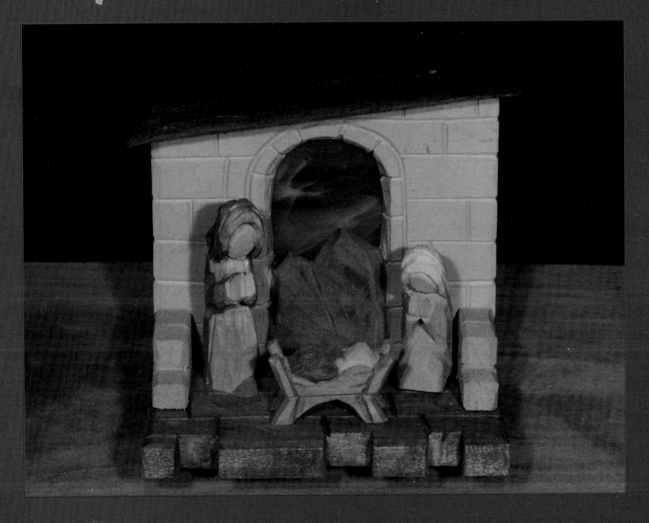

Schiffer Publishing Ltd

77 Lower Valley Road, Atglen, PA 19310

With photography by Steve Smith
& consultations by
Tom Brown, Mac Proffitt,
& Steve Smith

Dedication

From Larry: To Gandolf a wonderful Sheep Dog who kept me company in my wood carving shop. He faithfully stayed by my side during long hours of carving. He is missed.

From Mike: To Tim and Dave, two guys who've always been in the little square of my steering wheel.

Printed in China

ISBN: 0-88740-959-8

Book Design by Audrey L. Whiteside.

Library of Congress Cataloging-in-Publication Data

Green, Larry.
 First projects for woodcarvers: a pictorial introduction to wood carving/Larry Green & Mike Altman; with photography by Steve Smith and consultations by Tom Brown, Mac Proffitt & Steve Smith.
 p. cm.
 ISBN 0-88740-959-8
 1. Wood-carving--Patterns. 2. Wood-carved figurines. I. Altman, Mike. II. Title.
TT199.7.G7623 1996
731.4'62--dc20
 95-26063
 CIP

Published by Schiffer Publishing, Ltd.
77 Lower Valley Road
Atglen, PA 19310
Please write for a free catalog.
This book may be purchased from the publisher.
Please include $2.95 postage.
Try your bookstore first.

We are interested in hearing from authors
with book ideas on related subjects.

Contents

Introduction ... 5
The Projects ... 6
A Great Resource For The New Carver 7
Safety ... 8
Basic Tools Of Wood Carving 10
Helpful Items Used In Wood Carving 13
Wood ... 15
Sharpening The Tools 16
Knife Practice .. 20
Gouge Practice .. 24
The Cowboy Boot ... 25
Gandolf The Dog ... 33
The Nativity ... 44
The Rough Out .. 57
The Gallery .. 61

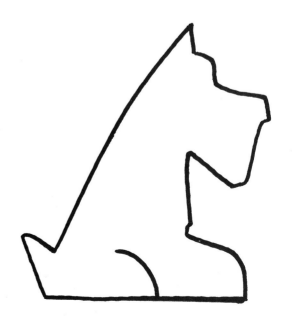

Acknowledgments

Tom Brown

Thanks Steve for all of your long hours of hard work shooting the photos. I really appreciate our friendship.

A special thanks to the folks at the Bountiful Golden Center Carving Club in Bountiful, Utah for their assistance.

Thanks to Tom Brown and Mac Proffitt for their consulting work.

Mac Proffitt

The *First Projects* Folks

Larry Green lives in Knoxville, Tennessee where he serves as Director of Admissions for Johnson Bible College. He is the author of *Carving Boots and Shoes, Caricature Relief Carving, Carving the Old Woman's Shoe,* and *Carving Comic Clocks.* He has been carving for over 20 years and is a member of the Southern Highland Craft Guild. Larry has taught carving at the John C. Campbell Folk School in Brasstown, North Carolina.

Mike Altman is a guy who likes to draw and be recognized. If you see him, wave and say hello. Mike has assisted Larry on 4 of his five books.

Steve Smith lives in Knoxville, Tennessee where he serves as a Professor at Johnson Bible College. Steve specializes in aquatic carvings with an emphasis on miniatures. He photographed the last four of Larry's books.

Tom Brown lives in Converse, Indiana and is retired from Chrysler Corporation. In 1994-97 he served as president of the Affiliated Wood Carvers and is currently president of the Eastern Woodland Carving club. He has served as a judge at various wood carving shows and teaches classes on carving around the country. Tom is a member of Caricature Carvers of America.

Mac Proffitt lives in Maryville, Tennessee. He is the owner of Smoky Mountain Woodcarvers Supply and School in Townsend, Tennessee. Mac has taught many classes to new carvers including carving classes at the University of Tennessee. He is currently the secretary of the South Eastern Wood Carvers Association.

Introduction

FIRST PROJECTS has been in the making since the first day I picked up a knife. If it had not been for a wood carver who was willing to teach me, I believe my attempts at carving would have ended in frustration. Since I do not have that natural talent, an artist's eye, I have had to really work at carving. Some of my friends tell me I have a lot more work to do. The men and women who have encouraged and given advice saved me wasted time and mistakes. My goals for FIRST PROJECTS are to inform, instruct, encourage, and challenge.

Mike and I, with the help of Steve Smith, Tom Brown and Mac Proffitt, have designed FIRST PROJECTS for the new woodcarver. You notice we did not include such words as "complete guide," "everything you wanted to know," or "a complete course" in the title. This is not a complete work on wood carving, but a starting place.

The general focus of the book is to introduce you to woodcarving safety, knives, palm carving tools, helpful items and "in the round" carving. In the round carving encompasses figures that are 3-dimensional; humans, birds, aquatic, animals. I encourage you to investigate chip carving and relief carving. There are many fine books available on these types of carving. When I started carving, full color, step-by-step books were rare. Now you can probably find a book on just about any subject you wish to carve.

The step-by-step cuts I make in the book are based on many years of carving experience. Each picture illustrates where the wood is to be removed and does not necessarily show the only way.

The Projects

I have been carving cowboy boots and various types of shoes for twenty plus years and have even written a book called *CARVING BOOTS AND SHOES*. My first project was a shoe, so I thought it was only fitting to include a cowboy boot. Most people enjoy carving animals, so what better project than a Mike Altman designed dog, Gandolf? We purposely made him in the sitting position so you would not have to be concerned about carving the legs on your first project. The nativity, of course, features human beings to carve. The faces and hands are stylized (no details have been added) to eliminate tedious work. Tom has included a project which we hope will be of help to you when you venture into carving a rough-out, a figure that is partially machined carved. He guides you through the preliminary areas of preparing the rough-out for adding details. I do hope you enjoy the projects!

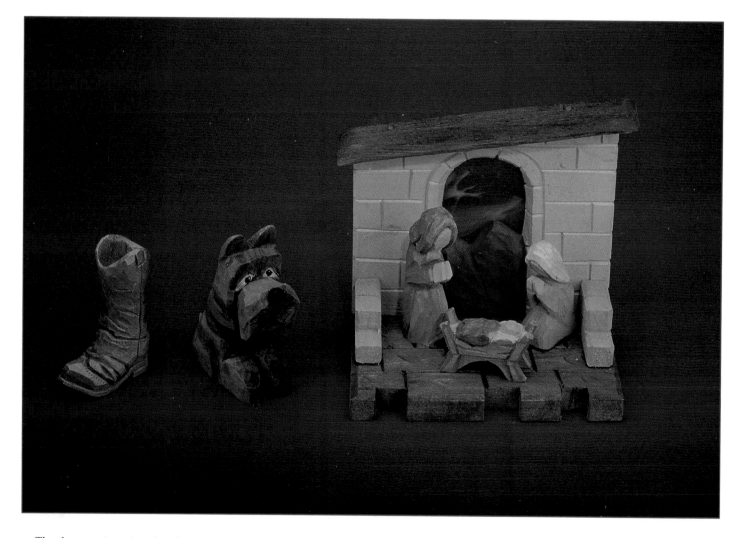

The three projects (cowboy boot, dog and Nativity) were selected because of their design. They are projects that can acquaint you with your tools, grain direction and proportions. The fourth project is for use sometime in your carving future.

A Great Resource
For The New Carver

One important resource for the wood carver is The National Wood Carvers Association, 7424 Miami Ave. Cincinnati, OH 45243. In 1995 they had a membership of more than 56,000 members. The membership is growing every day. I encourage you to contact the NWCA for membership information.

The Association publishes a bimonthly magazine called *Chip Chats*. It contains articles on carving, tool sharpening, press releases on new books, reports on carving shows. Each issue contains a calendar of wood carving events across the nation. The March-April issue contains the Annual Sources of Supply Listing of books, tools & supplies, workbenches, woodburners, patterns, blanks, rough-outs, kits and videotapes.

The NWCA can provide you with the addresses of wood carving clubs in your area. When you write the NWCA for information, include a self-stamped address envelope. NWCA is a non-profit corporation.

Safety

Safety is an important consideration in wood carving. You can do your body damage when the knife or gouge slips and finds its way into your hand or leg. You will be using sharp knives and carving tools so the potential for injury is always present. No one is exempt from being cut. We have included safety tips we encourage you to consider.

SAFETY TIP # 1: **Think before you make a cut!** If the tools slips, where is it going to go? Will it go into your hand or leg? You should never cut toward exposed skin. It is easy to get so focused on removing the wood to create a work of art that you forget the danger involved with the knife or gouge. Also, don't hurry! Wood carving is an art form to be enjoyed not a race against the clock.

SAFETY TIP #2: **Protect your non-carving hand and fingers by wearing a carving glove.** The glove provides good protection but should not be considered as absolute protection. Some gloves are made with Kevlar, Spectra and stainless steel. You should clearly understand the manufacture's instructions and cautions for their carving glove.

SAFETY TIP #3: **Wear a thumb guard.** This protects the thumb of your carving hand when the knife slips off the wood or you cut through the wood in the direction of the thumb. It provides no protection for your non-carving hand. It is a safe idea to wear a thumb guard with a carving glove. The thumb guard should not be considered absolute protection.

SAFETY TIP #4: **Carve with a sharp knife and gouges!** A dull knife or carving tool is dangerous, leaves scars and scratches on the wood, tears up details, and wears out the hand. A dull knife tends to slide or bounce off the wood. I'm using a strop to produce a razor edge on my knife.

SAFETY TIP #5: **Do not force the knife or carving tool through the wood.** I know this does not seem to make sense but there is a fine balance between letting the knife or carving tool do the work and forcing it to cut more wood than your hand strength, tool sharpness, and skill level allow. If you cannot push or pull the knife or tool smoothly through the wood, remove it from the cut and try again, this time attempting to remove less wood. In time, as the knife hand becomes stronger and more controlled, you should discover yourself removing more with each cut. Remember that wood carving is not an art form of strength (how much wood you can remove with each cut) but a patient effort of transforming a piece of wood into an object of beauty.

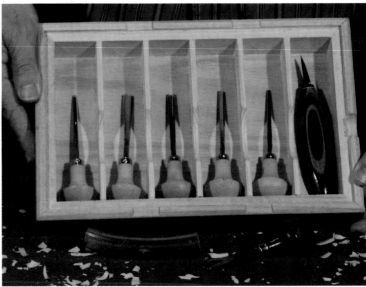

SAFETY TIP #6: **Store your knives and tools properly. You should always keep knives and tools out of the reach of children!** A simple box with dividers works. You do not want to reach in the an unorganized box and contact the edge of a knife or gouge. Believe me it hurts! You can use clear plastic hose as a simple holder for each carving tool and knife. You need to keep the sharp edge of the tools from banging against one another and dulling the edges. I made this holder for my knife and gouges...

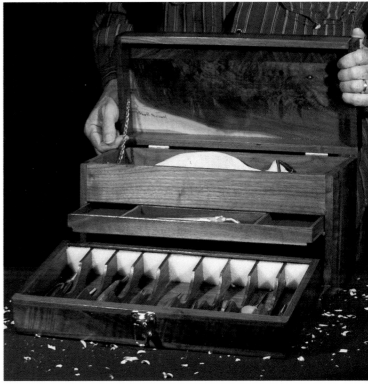

or you can build or buy a case designed just for wood carving tools.

Basic Tools Of Wood Carving

The Knife

Woodcarving requires a sharp knife. Some carvers prefer to carve only with a knife. In FIRST PROJECTS, we encourage you to use additional carving tools along with the knife.

A sharp knife is the foundational tool of the wood carver. The knife becomes the extension of your eyes, hands, mind, and heart. It transfers your imagination, skill, and creativity to the wood.

You can choose a replaceable blade knife. The blades are usually razor sharp and available in a variety of sizes and shapes.

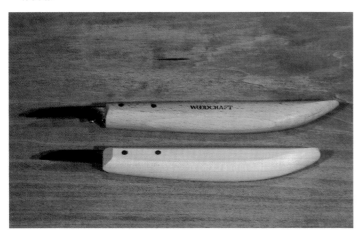

You have several options for knives. You can choose one like I started with, a bench knife. This style of knife remains extremely popular with carvers. For the FIRST PROJECTS in the book, you need a knife with a blade similar to the one on the bench knife. I recommend a blade length of approximately 1½" inches. I have found that the shorter the blade, the more control. When you purchase a knife, ask the supplier if the knife is sharp and ready to use or if it needs work on a sharpening device such as a stone, diamond hone and strop. Some suppliers offer sharpening services. I encourage you to try different knives and blade styles. In most carving projects, it can be helpful to have more than one knife. Experimentation and experience help you select the best knife blade for your carvings.

You can choose a custom knife and can expect to pay from $20 to $75 each. Most come with a blade that is usually razor sharp and ready to use.

Other Carving Tools

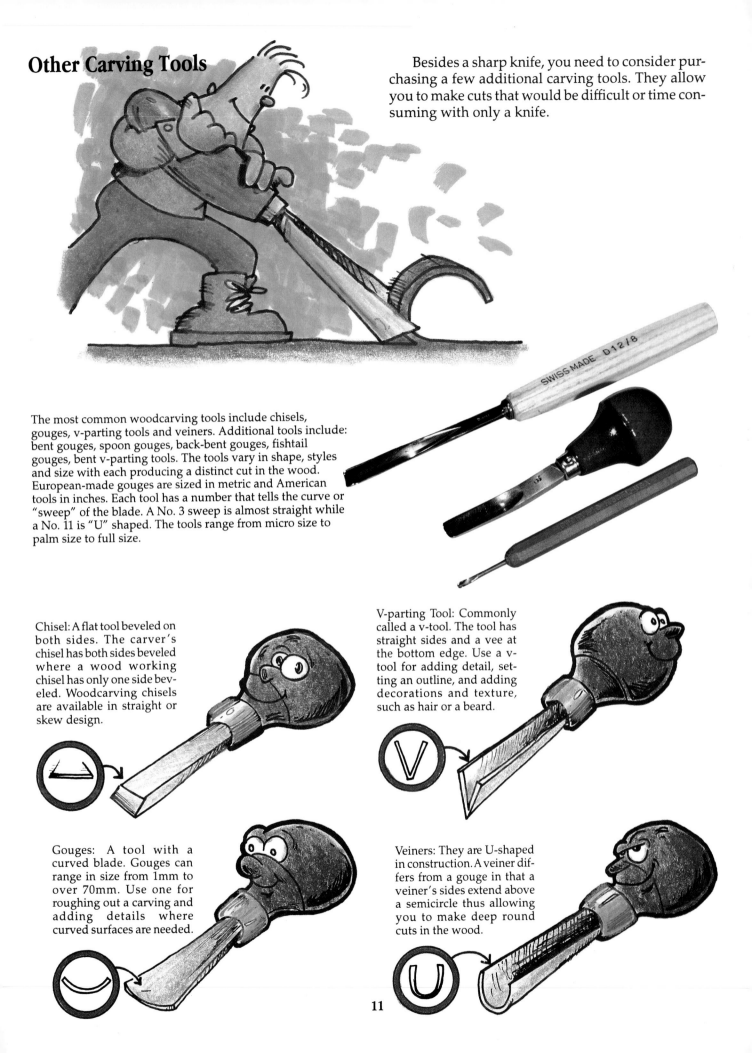

Besides a sharp knife, you need to consider purchasing a few additional carving tools. They allow you to make cuts that would be difficult or time consuming with only a knife.

The most common woodcarving tools include chisels, gouges, v-parting tools and veiners. Additional tools include: bent gouges, spoon gouges, back-bent gouges, fishtail gouges, bent v-parting tools. The tools vary in shape, styles and size with each producing a distinct cut in the wood. European-made gouges are sized in metric and American tools in inches. Each tool has a number that tells the curve or "sweep" of the blade. A No. 3 sweep is almost straight while a No. 11 is "U" shaped. The tools range from micro size to palm size to full size.

Chisel: A flat tool beveled on both sides. The carver's chisel has both sides beveled where a wood working chisel has only one side beveled. Woodcarving chisels are available in straight or skew design.

V-parting Tool: Commonly called a v-tool. The tool has straight sides and a vee at the bottom edge. Use a v-tool for adding detail, setting an outline, and adding decorations and texture, such as hair or a beard.

Gouges: A tool with a curved blade. Gouges can range in size from 1mm to over 70mm. Use one for roughing out a carving and adding details where curved surfaces are needed.

Veiners: They are U-shaped in construction. A veiner differs from a gouge in that a veiner's sides extend above a semicircle thus allowing you to make deep round cuts in the wood.

11

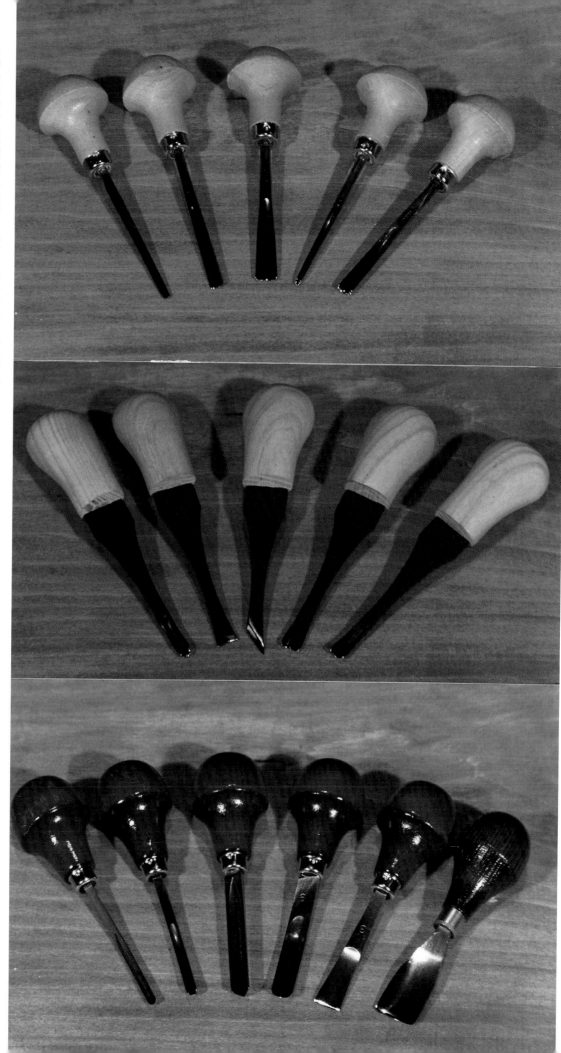

Advice on which tools, sizes and how many to purchase will vary depending with whom you talk and what you plan to carve. Since this book focuses on the new carver, we suggest the purchase of palm carving tools. If you plan to carve larger projects, we suggest you find a carver and discuss tools for larger projects with him or her. You can purchase a set of palm carving tools or buy one or two tools at a time and add to your collection as you progress with carving. Palm carving tools come in various handle shapes, sweeps and sizes. Pictured is a set of Swiss-made tools. I thank Woodcraft Supply, of Parkersburg, West Virginia for these tools.

The Flexcut™ palm carving tools have a unique design. They feature a spring shank that can change as the contour of the wood dictates. In addition, the tool has an ergonomically designed handle.

Every carver has favorite sizes and shapes of carving tools. Their favorites are chosen based on the type of carving they do, the "feel" of the tool, performance, and the ability to hold a sharp edge. What might be just right for someone else might not be just right for you. Tom Brown, who carves caricatures, suggests a set of palm carving tools for carvers that allows one to tackle most small to medium size projects. We want to thank Larry Yudis at The Woodcraft Shop in Bettendorf, Iowa for supplying the palm carving tools. Tom's 6 favorite tools are (from left to right) a 5/32" V-parting tool, 3/16" No. 11 veiner, 5/16" V-parting tool, 3/8" No. 9 gouge, 1/2" No. 3 fish tail gouge, and a 3/4" No. 3 gouge.

Helpful Items Used In Wood Carving

Besides a knife and carving tools, there are several helpful items you can use. We have selected a few and given a short explanation of each.

There are several power aids designed for sharpening. We encourage you to talk with an experienced woodcarver who uses these aids. A) **Wet/Dry grinder:** A grinder that features a water wheel; B) **Buffing wheel:** A cloth wheel that mounts on a bench grinder. Other wheel materials, such as leather or felt, can be used; C) **Bench grinder:** An tool to which a buffing wheel and sharpening stone are attached. D) **Buffing compound:** An abrasive substance applied to a buffing wheel or strop to help produce a razor edge on a knife or gouge. Some more popular compounds are Yellowstone and Zam, and jeweler's rouge also work well.

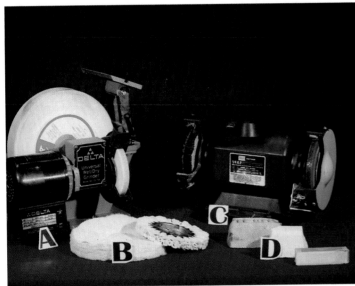

Eye punches: A circle punch which, when pushed into the wood and rotated, produces the round curved surface of an eye, button or various details.

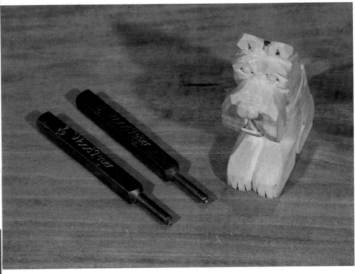

Pounce wheels: tools that can be used to add stitching to boots and clothes. I want to thank Smoky Mountain Woodcarver's supply in Townsend, Tennessee for providing the pounce wheels.

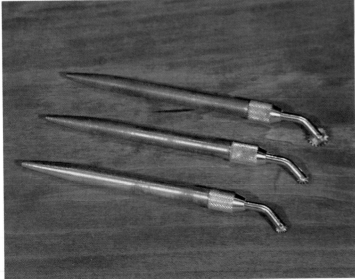

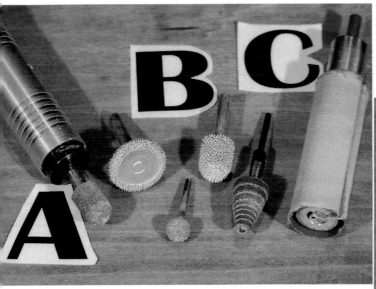

Flexible shaft tool: A high RPM rotary tool used for detailing, drilling, general shaping and roughing. A) flexible shaft handles usually allow for interchange of tools. I have a tungsten carbide burr in mine B) tungsten carbide burrs, C) sanding cones and drums, and (not pictured) drills.

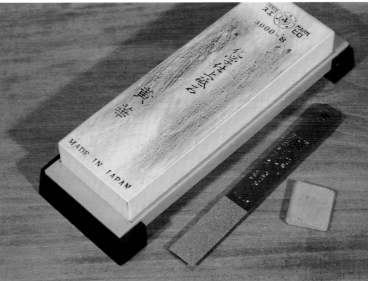

Sharpening Stone: An abrasive stone used to sharpen knives and gouges. The stones are classed according to their abrasiveness (grit) and are either natural or synthetic. Some of the popular natural stones are India, Washita, Soft Arkansas and Hard Arkansas. Another type of sharpening stone is a EZE-LAPE™ Diamond Hone & Stone. The smaller stone is a round slipstone and is used on the inside of gouges. Slipstones also come in tapered triangles, knife edge, rounds and points.

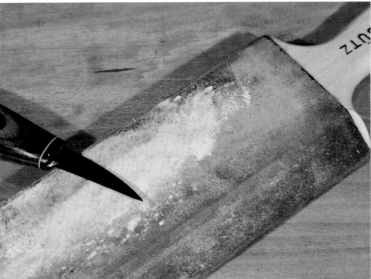

Strop: A tool used for the final step of the sharpening process. It is constructed of wood with a layer of leather attached. The leather is treated with an abrasive compound such as Yellowstone or Zam.

Woodburner: An electrical tool used to burn details into wood. The woodburner usually has interchangeable tips. I thank my good friends at Woodcraft Supply in Parkersburg, West Virginia for the Swiss made palm carving tools, flexible shaft tool and the woodburner.

Wood

What is the best type of wood for carving? Basswood (Linden) is the preferred wood for most carvers. It is a hardwood with dense grain that lends itself to details. Basswood usually is free of knots.

Other woods for most projects include Buckeye, Butternut, Sugar or White Pine, and Walnut. Duck and bird carvers usually prefer Tupelo.

Sharpening The Tools

To have an enjoyable experience in carving, you need sharp tools! The quality of the blade steel, how it is sharpened, how you use it, the kind of wood you are carving, and the amount of carving determines how long a knife stays sharp. **A dull knife or carving tool can be dangerous, leaves scars and scratches on the wood, tears up details, and wears out your hand.** There are as many different approaches to sharpening as there are carvers. If you want to get a conversation started, ask a carver how he or she sharpens tools! Go to another carver and you will probably get a different answer.

This book is not the authority on sharpening. We believe the quickest method for sharpening is through the use of power equipment. We realize, however, that you may not have the space, interest, or ability to invest in the necessary power equipment. It is important to gain an overview of the fundamentals. We are sharing what has worked for us.

You need to remember what I call the three "P's" of sharpening. **Number 1: Patience**: Do not be in a hurry. The extra time you spend sharpening/honing can eliminate dull tools, tired hands, and maybe even an injury. **Number 2: Position**: You need to understand the proper position/angle of the tools on the stone, strop, or buffing wheel. Without the correct angle you can end up dulling or damaging your tools. We recommend you keep the knife flat on the stone and strop. **Number 3: Practice**: Like carving, sharpening is going to take some practice. Most things we attempt we get better at through practice. However, if you find that you just cannot get your knife or gouges sharp, find a carver who is willing to help. Don't let your carving days end in frustration because you cannot get the tools sharp.

There are two important tasks involved in preparing and maintaining your tools for carving. They are sharpening and honing. You also need to understand two important terms that are associated with these tasks. They are wire edge and bevel.

What is a wire edge? It is sometimes called a "burr". As you sharpen, the metal edge becomes thin and curls up on the top of the blade. The wire edge appears on the side facing up from the stone. It does not form on the side of the blade against the stone. This wire edge signals that a new edge has developed. The thickness would be thinner than aluminum foil.

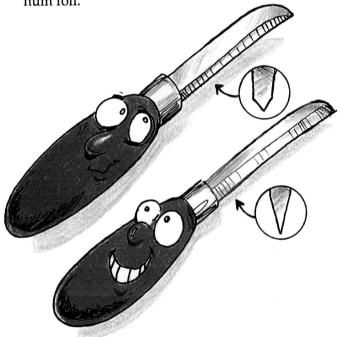

The knives show two types of bevels. On the left is a short bevel (which is usually found on most new unsharpened carving knives) and on the right a long bevel. Tom, Mac, and I prefer knives and carving tools with long bevels. They cut through the wood easier. If you purchase a knife or gouge with a short bevel, we suggest you consider extending the bevel. The short bevel is primarily for working in hardwood such as walnut or oak. The longer bevel is more suited for work in woods such as basswood and buckeye. Changing the bevel on a tool is accomplished with a stone. Power equipment can do the work more quickly, but will require more skill and practice. Before trying to change the bevel on a knife or gouge, we suggest you locate a woodcarver who has experience in this area. His or her experience can help you eliminate mistakes.

TASK ONE: SHARPENING. **Use this step if the knife or gouge is new (unsharpened), damaged, dull or is in need of the blade bevel being changed.** Sharpening requires using a stone (Soft Arkansas or similar stone, Diamond hone, or a power device). You need to follow the manufacture's instructions for the use and care of a stone. Sharpening produces a wire edge on the cutting edge.

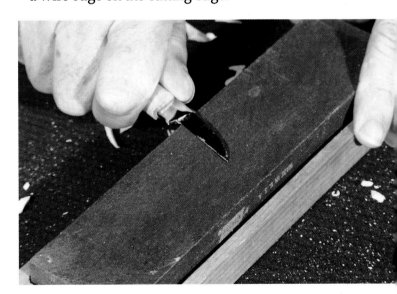

To obtain a wire edge, place the knife flat on the stone with the sharp edge facing away from you. Exert pressure on the blade and pull the knife toward you. Take a few strokes and check for the wire edge. It must appear on the length of the blade. **Most new carvers do not continue the sharpening process until the wire edge appears.** Continue this action repeatedly until the wire edge appears on the side of the knife facing up. Some carvers use a magnifying glass to check for the wire edge. Others use light and allow it to reflect on the blade and see the wire edge by this means. The wire edge is not a flat surface so light does not reflect off it. The wire edge needs to form the complete length of the blade. Remember the 3 P's: Patience, Position and Practice.

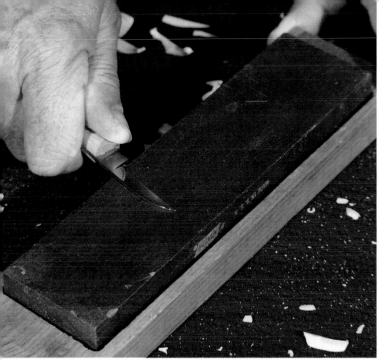

After you have produced a wire edge on one side, turn the knife to the other side and work to produce a wire edge. As you work on this side, the wire edge from the other side will eventually curl up. Exert pressure on the blade and push the knife away from you with the sharp edge facing toward you. Continue this action repeatedly until a wire edge appears on the cutting edge. When it appears on this side, you are finished with this step.

TASK TWO: HONING. **Use this step on a knife or gouge to remove the wire edge formed by the stone and fine scratches left by the stone. Once a knife is sharp you can use this step to maintain a razor edge.** If the blade has been sharpened properly, you should **only need** to return to the stone if you break or chip the blade or if you wish to change the shape of the blade. Honing is accomplished with a fine grit stone and a strop. Each time you start to carve, give the knife blade a few licks on the strop to maintain the razor edge. This also will remove any moisture that may have collected on the blade through storage. **When you are carving, it is a good idea to periodically use the strop to maintain the edge.**

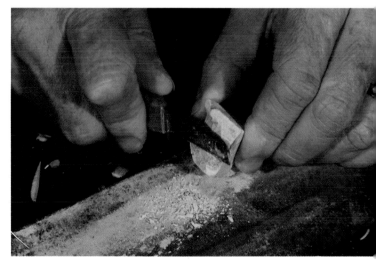

Obtaining a wire edge during the sharpening process applies to gouges and v-tools as well. However, you must rotate the edge of the tool from side to side across the stone for a gouge. You only produce a wire edge on the inside of a gouge or v-tool. For a v-tool you must work the tool so you maintain the vee at the bottom. The v-tool is the most difficult to sharpen. Care must be used not to sharpen one side more than the other. We suggest you seek the assistance of an experienced carver for the v-tool.

Hone with a fine grit stone, such as hard Arkansas, and a strop. You can use a fine grit stone to remove scratches left by a more abrasive stone. I use a 3000 grit stone for the honing process and then finish with a strop. To use a strop, spread the abrasive compound on the strop. I am using Yellowstone. I just scrape it off the block onto the strop.

18

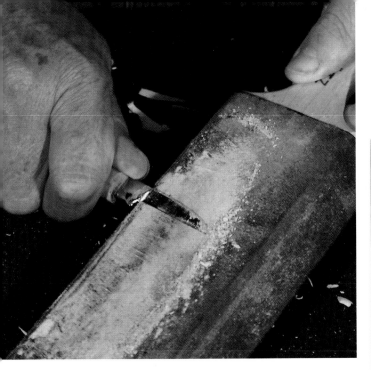

Place the knife flat on the strop and keep it flat, with the sharp edge facing away from you. While exerting pressure on the blade (this helps keep the blade flat), pull the knife toward you and then turn the knife over and push it away from you. Continue going in both directions until you have removed the wire edge and any scratches left by the stone, and have produced a mirror finish on the blade. Remember the 3 P's: Patience, Position and Practice.

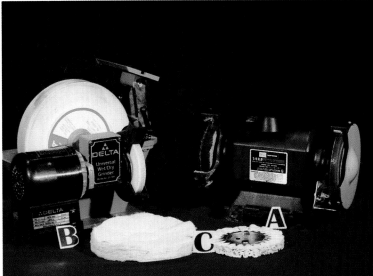

Use a round edge slipstone or piece of leather to remove the wire edge from inside the gouge.

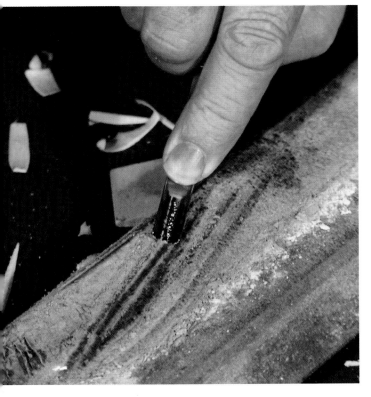

A gouge is honed by rotating it from side to side along the strop, keeping it flat along the bevel.

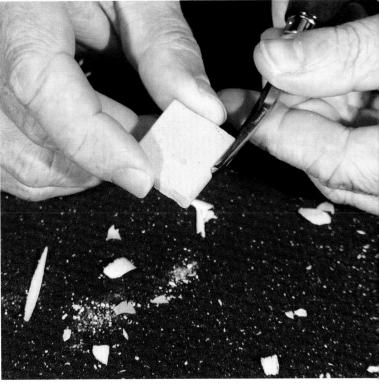

To speed up the sharpening/honing process, you may want to consider investing in power equipment designed for sharpening and honing. The photo shows a small sample of the many products available. A: Bench grinder, B) Wet/Dry grinder; C) Buffing wheel. Consult an experienced carver who is familiar with power assisted sharpening before investing in this equipment. Proper safety techniques must be utilized with this equipment.

Knife Practice

This section can help you become familiar with the knife and some basic cuts you will be making in *FIRST PROJECTS* and on future carvings. Different carvers might call these cuts by other names. There does not appear to be a consensus on the terms. You will find yourself repeating these cuts again and again. The best way to teach you is to show the cuts and then for you to practice on a scrap piece of wood. **I strongly suggest you use a carving glove and thumb guard for these practice cuts. For purposes of illustration, I am not carving with a thumb guard so you can better see the position of my thumb.**

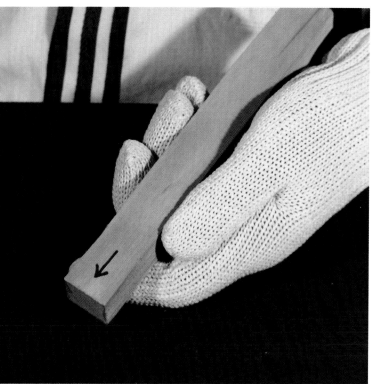

I am using a piece of basswood 8 inches long, 3/4 inches thick and 1 inch wide. The arrow shows the grain running the length of the piece. You can use whatever size you have available. Just make sure it is large enough so you can get a good hold. If you cannot find basswood, I suggest you use sugar or white pine. I discourage the use of yellow pine, used for shelves and 2 x 4's. It contains sap and knots that can dull the tools. Besides that, it's just plain hard to carve. However, if yellow pine is all you can find then you have to use what you have. I have painted my practice board with a blue wash to help the cuts stand out. You do not need to do this to yours.

THE PULL CUT: This is the workhorse cut of carving. You can use this cut to do most of the wood removal and shaping on a project. It's like making a fist over and over. Maintain a firm grip on the practice wood. You do not want it slipping out of your hands. Place your thumb below the path of the knife. Place the knife in the wood and gently pull the blade toward the end/edge of the wood. **Keep the thumb out of the path of the knife. If you have a thumb guard, I suggest you use it.** Make several cuts completely around the wood. Vary the starting point of the knife. This will give you a "feel" of how it requires more strength to pull the knife the farther away it is from your thumb. Vary the depth of the cut until you find the depth that feels most comfortable. DO NOT FORCE THE KNIFE. If it does not pull smoothly through the wood you need to stop and attempt a shallower cut.

The PULL CUT in action on the cowboy boot.

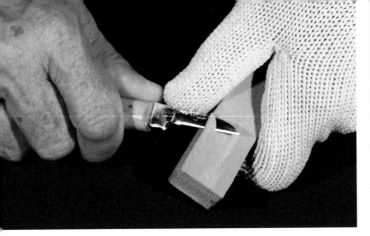

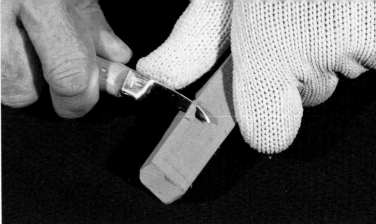

THE PUSH CUT or CONTROLLED CUT: This cut is used when the direction of the grain or location of the cut will not allow you to use the pull cut. This cut requires a little more coordination of the hands. Place the knife on the wood and place the other thumb on the back of the blade or on the back of knife hand thumb. While firmly holding the wood, exert pressure on the back of the blade, pushing the knife through the wood. Work your way around the practice wood. Vary the depth and length of cut. DO NOT FORCE THE KNIFE.

Step 2: Place the knife on the wood, adjust the angle of the blade to match the depth you want to reach and slowly use the push cut to move the knife blade into the stop cut. In some situations, you might use the pull cut to cut back to a stop cut. The piece of wood should pop loose. The angle of the knife needs to match the depth of the stop cut at the point where the two cuts intersect.

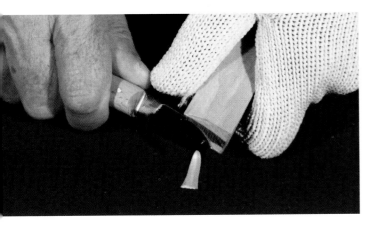

The PUSH CUT completed. Repeat the cut several times until you feel comfortable.

The push cut being made toward a stop cut on the nose of the dog. Notice how my thumb is exerting pressure on the back of the knife blade.

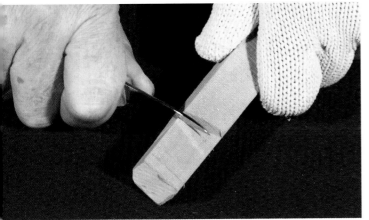

THE STOP CUT: Use this cut to control the movement of the knife, v-tool, or gouge through the wood. You can use this cut when shaping or detailing a particular feature on a project. It is a two step cut. **Step 1**: Place the knife on the wood and push it in firmly. This is a stop cut! It can also be made with just the point of the knife cutting into the wood. This is called **incising.**

The pull cut being made toward a stop cut on the nose of the dog. Notice how my thumb is exerting pressure on the back of the knife blade.

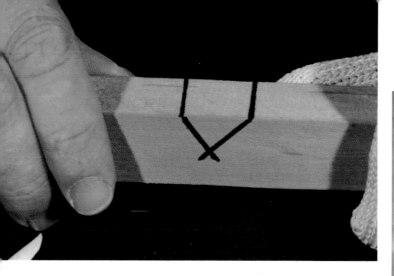

THE LINE CUT: This is a two step cut. Use the LINE CUT to remove wood where you want to reset or separate the wood between two areas. The line cut can be used to define the separation between an arm and the body or a coat and shirt, anywhere details come together that you want to separate. I drew this large so you can see how the two cuts should overlap.

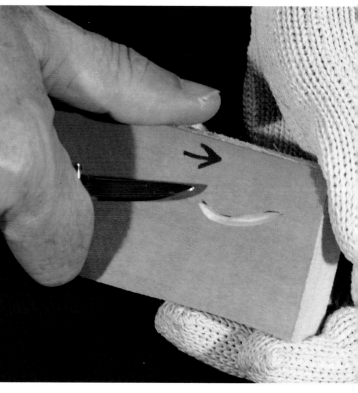

The completed cut.

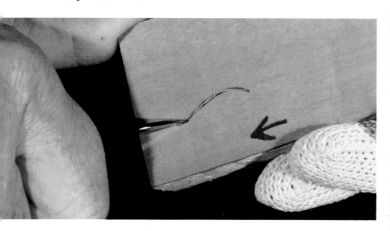

Following the line, make a cut at an angle along the surface of the practice wood.

The line cut is being used to separate Joseph's cloak from his robe.

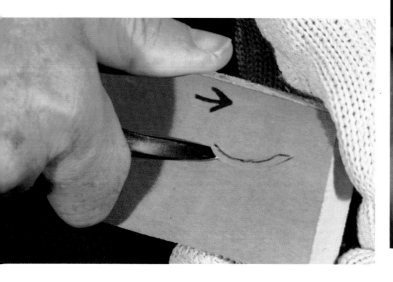

Rotate the wood and follow the line with the same angle and depth of cut. It is important to rotate the wood so the knife is at the correct angle and position for the cut. The wood should pop out.

22

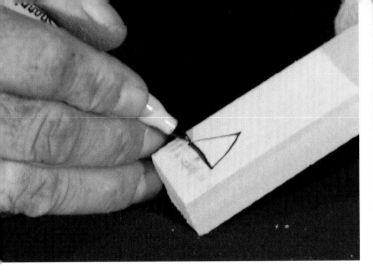

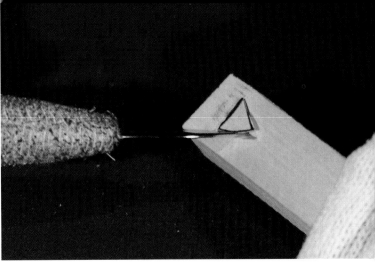

THE PYRAMID CUT: This is a three step cut. The three sides will not always be the same length. It is a combination of cuts made in the shape of a triangle. Use the pyramid cut to remove wood from such areas as the corner of an eye, to recess a mouth, to add detail to clothing, to add wrinkles next to a belt. You can find several uses for this cut and in most cases not even be aware you are using it. **You need to draw several small triangles on your board.** So you can see better, we have made a large triangle.

Make a third cut along the third side.

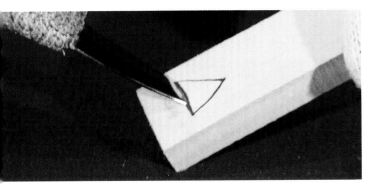

Make a deep cut at a slight angle along one edge of the triangle.

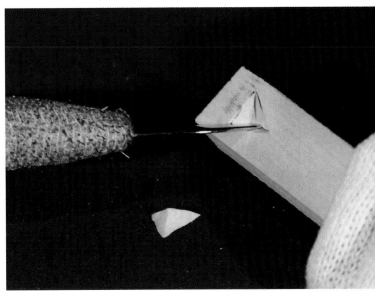

If the knife angle and depth have been correct, the pyramid should pop out.

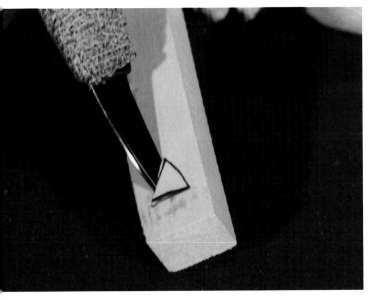

Make a second cut along the second side of the triangle. It does not matter which side.

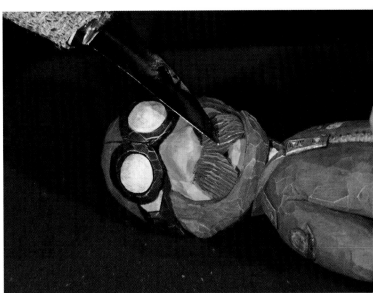

The aviator's mouth shows a perfect example of a pyramid cut.

Gouge Practice

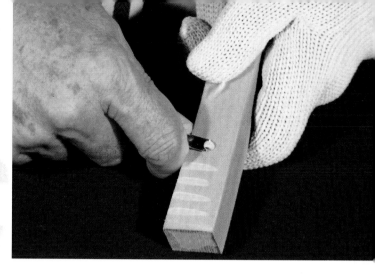

Practice pushing the gouge through the wood. Vary the depth and direction as you work your way down the board. During this practice session, you can tell if the gouges are sharp. If they do not cut smoothly or tear the wood, you need to do some more sharpening work on them.

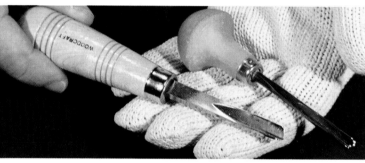

With a gouge, v-tool, or veiner you can make cuts and details that are difficult with a knife. Since, we will be using palm carving tools for our *FIRST PROJECTS* we will practice with one. You should always keep your non-carving hand out of the path of the carving tool.

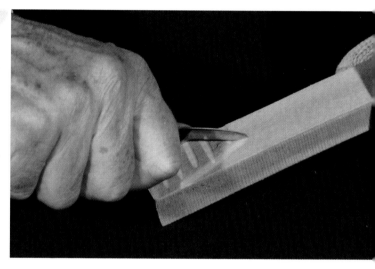

Use the knife to make a stop cut in the middle of the board.

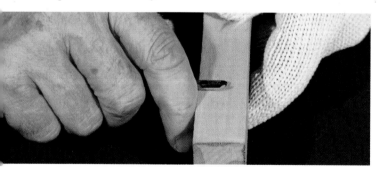

I prefer to hold the palm tool so my fingers act as a stop/brake to prevent the tool from racing wildly across the wood. You can see how the finger restricts or slows the movement. When you are carving, you should discover ways to use your fingers to restrict the movement of the gouge through the wood. You have much better control of the palm tool this way.

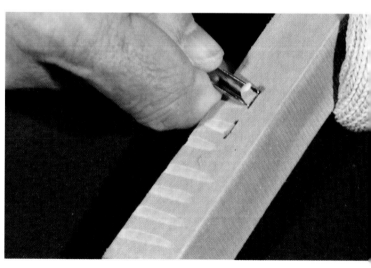

Push your tool up to the line stopping at the cut. Easy? The wood should pop out if the stop cut was deep enough to match the depth of the gouge cut. Continue to practice until you feel comfortable with the tools.

24

The Cowboy Boot

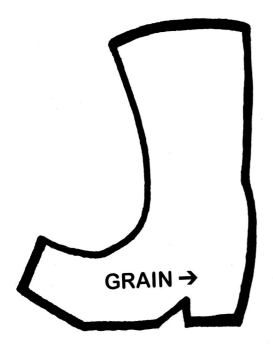

GRAIN →

Draw a center line on the front and back of the boot. This aids in the rounding process. I have put on a carving glove just in case the pen slips.

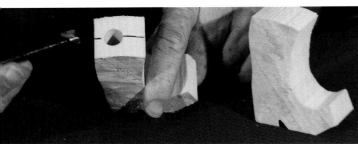

Trace the pattern on a 1 to 1-1/4" inch thick basswood board and then cut it out with a bandsaw or coping saw. **The grain runs from heel to toe.** Some carvers prefer to carve the boot with the grain running from the heel to the top of the boot. I like it running across the boot from the heel to the toe. You might want to try one with the grain direction running up and down to see the difference. If you have a drill press, use a 1/4" Forstner bit to set the position of the inside. Drill the hole at least 2 inches deep. Drilling the hole just speeds up the carving process when we are ready to finish the inside. If you don't have a drill press, you are ready to start carving.

Draw on the heel and sole. My boot is for the left foot.

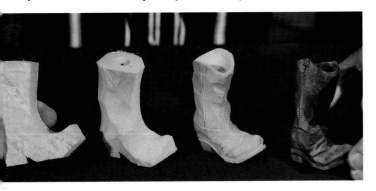

This series of boots shows the flow of the project. Blank, roughed out, the details added, and the completed work.

We will begin the carving by shaping the instep and heel. Don't try to remove all the wood to the instep and heel line at once. Take your time. I am wearing a carving glove and thumb guard. Both of these items are a good idea and investment.

The completed cuts.

Shape the toe of the boot. Remove the wood to the sole lines. Don't worry about the top of the toe. We will carve it later.

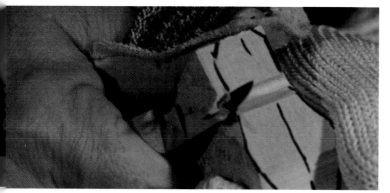

Shape the other side of the instep and heel.

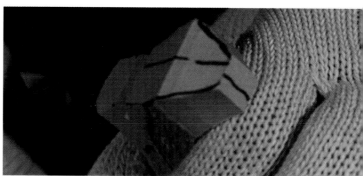

The wood has been removed to the sole lines.

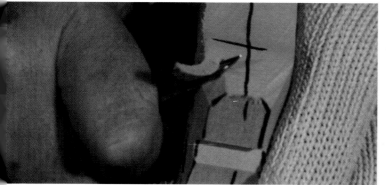

Draw a reference line 1 inch up from the heel on the back of the boot and then shape the back of the heel to that reference line.

Remove the saw marks from the front of the toe.

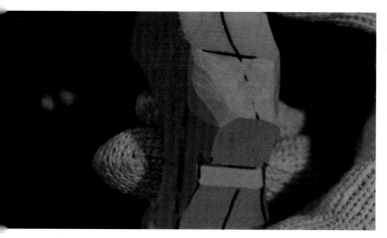

The completed heel.

Shape the toe to the center line. This will take a couple of cuts to get the wood removed to the shape you desire.

Shape the other side. All saw marks should be removed from the sides of the toe.

The completed work on the toe.

Draw the top of the boot.

Set the shape of the top by trimming away the four corners of the boot to the lines.

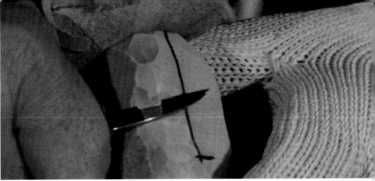

Carve the upper part of the boot, keeping in mind the shape on the top of the boot. While removing wood toward the center line maintain that shape down the length of the boot all the way to the ankle. You can see how the thumb guard can be of help, if the knife slips off the wood.

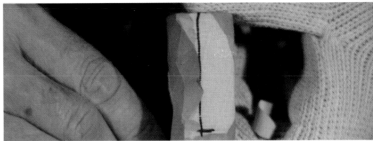

The completed rounding of one side. Continue the rounding on the other side.

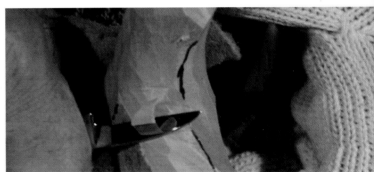

Round the boot on the front side to the center line. Repeat on the other side.

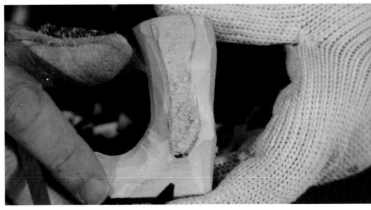

This picture shows the front and back rounded and the wood that has been left on the side. The other side of the boot should look similar.

Round the sides of the boot into the front and back.

Shape the top of the toe to your liking.

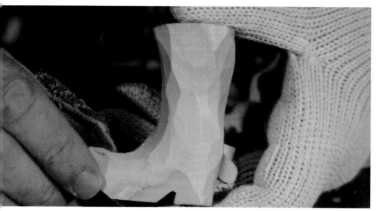

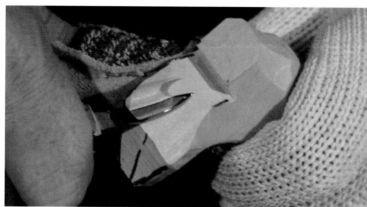

The completed rounding.

Remove the saw marks from the sole and heel of the boot. Don't dig in. Just shave them off, smoothing the surface.

Remove some wood just above the reference line. Removing the wood will cause a mound to form where the heel fits into the boot. Look ahead to the next picture before making these cuts.

Once you get everything shaped, it's time to look over the boot removing any saw marks and adjusting any features with which you are not satisfied. As I look at the toe on my boot, it seems too wide. I am going to make the toe just a little more pointed.

At the one inch mark you can see how the back of the boot is reset some.

The finished toe.

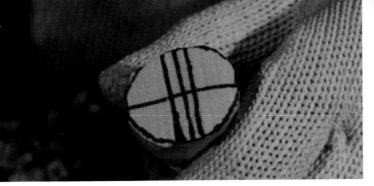

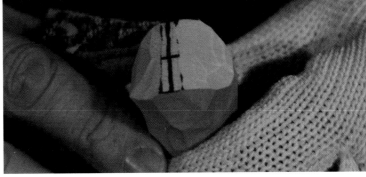

At the top of the boot draw a center line from front to back and one from side to side. Add a line on each side of the center.

The completed cuts. You will notice that I have left a high point in the middle. This is where I will later carve the boot pulls on the side.

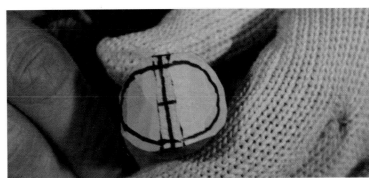

Draw a reference line 3/8 inch from the top on the front and back of the boot. This sets the depth of cut for the top of the boot, in the front and back.

Draw the boot wall.

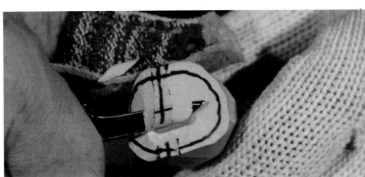

Remove the wood to the reference line. Look ahead to the next picture before making this cut.

Use the knife in a scooping motion to remove wood within the boot wall lines. Continue to remove wood to the level of your marks. Don't cut them off. If you drilled a hole with a drill press, follow the same procedure as pictured.

The front has been shaped. Repeat this procedure on the back half of the top.

It's time to remove wood from the center of the boot. Use carving tools similar to a 10mm No. 5 and a 5mm No. 9 gouge.

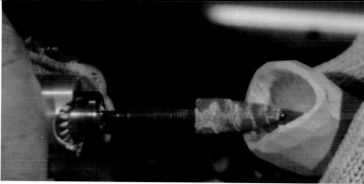

Remove wood from the inside of the boot. I am using the 10mm No. 5 gouge. **Great care should be used so you don't cut through the side of the boot or cause the gouge to slip off the boot and into your hand.** Work you way around the inside, using a shaving motion on the boot walls. I am using my finger to control the gouge. It is next to the boot. This gives me better control of the gouge. You can always clamp the boot in a vise and use both hands on the gouge.

After using the carbide burr, I switch to a sanding cone for the final finish work. The sanding cone removes any marks left by the burr.

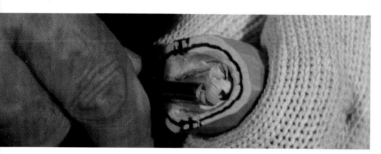

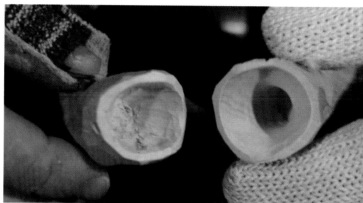

I have changed to the 5mm No. 9 gouge to remove more wood. Use whatever works best for you.

This picture shows the difference between a boot completed with only a gouge (on the left) and one completed with the aid of power (on the right).

Once you have removed the wood on the inside to your liking, cut the marks off the top of the boot. Shape the sides of the boot until you reach a uniform thickness all the way around the top.

Draw the sole and heel.

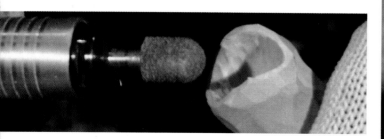

If you have some type of flexible shaft tool, add a carbide burr to it and do some shaping of the inside. If you don't have a tool, you need to do some additional work with your gouge to clean up the inside.

Deeply incise the line around the boot. The deeper the incised line, the cleaner the top of the sole will look after cutting to the incised line. This is a stop cut.

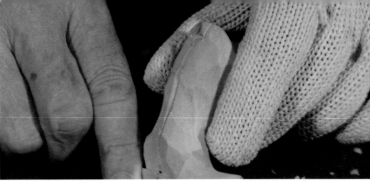

Trim back the incised line from the body of the boot. This cut sets the shape between the sole and the body of the boot. The deeper the angle of cut the wider the sole. Personal preference and practice determines angle and depth. This will take several cuts to work your way around the boot. Use care cutting back to the incised line! Since the wood is thin, you can cut through the sole and into your thumb or hand.

The completed work on the pull strap and seam.

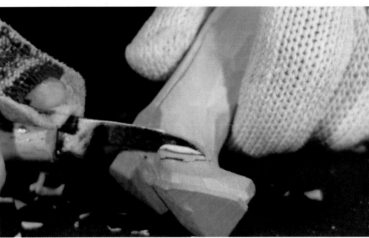

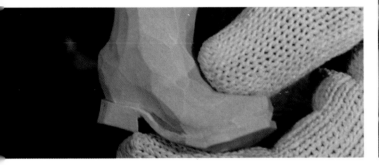

The completed work on the sole.

To add wrinkles, make several v-cuts with your knife. You can use the v-tool to make the wrinkles.

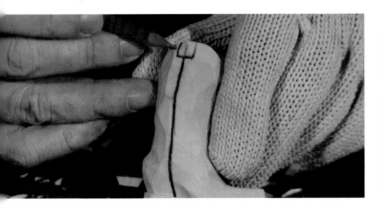

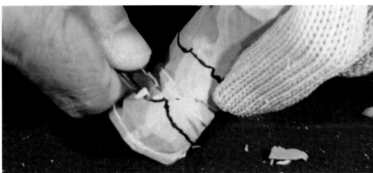

Draw the pull strap and the seam down the side of the boot. Repeat the other side.

Add any details you would like with the v-tool. I am adding a seam on the toe and around the ankle. If you own a pair of cowboy boots, it would help to take a look at them for this step.

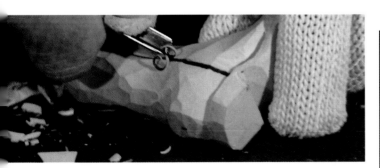

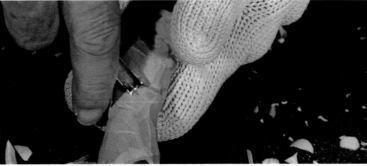

V-tool around the pull strap and then run the v-tool the length of the boot to create a seam. If you don't have a v-tool, incise the lines with the point of the knife. The v-tool helps the seam stand out better. Repeat the other side.

Use a v-tool to add some wrinkles to each side of the boot.

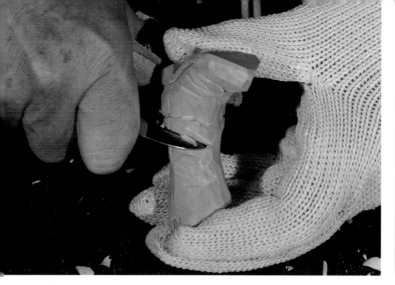

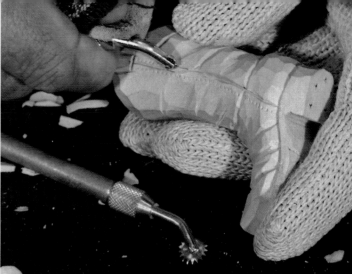

Use the knife to remove some wood from between the v-tool cuts. This gives the boot more character.

You can use the point of your knife or a pouch wheel to add some stitching marks.

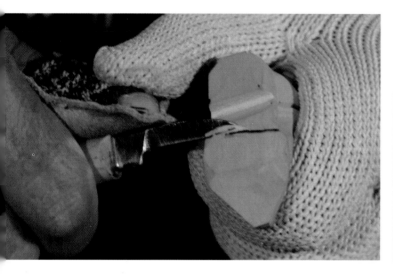

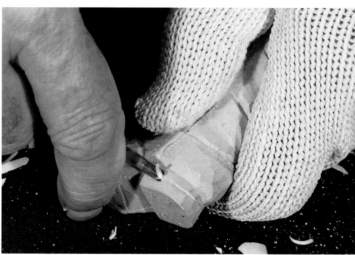

Draw a half sole and incise the line and then cut back to the line.

Use a small v-tool to separate the heel from the sole.

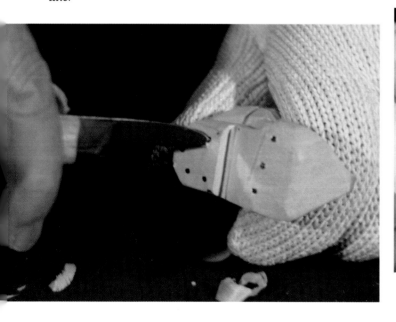

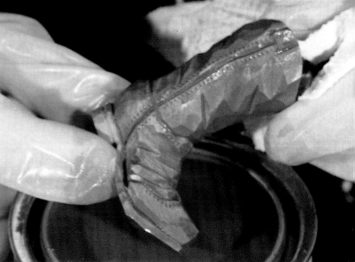

Put some nails in the heel and sole by sticking the point of the knife in the wood and twisting it a little.

To complete the carving, I dunk it in a can of stain for a few seconds. I am using Minwax™ Colonial Maple stain. Wipe off the excess stain with a towel and allow the boot to dry. Finish with a coat of wax.

Gandolf The Dog

Mike designed Gandolf so that there is not a lot of wood removal on the project. The purpose of the project is to help you become accustomed to your knife without having to focus on a lot of detailed features.

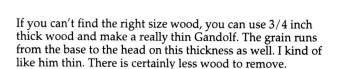

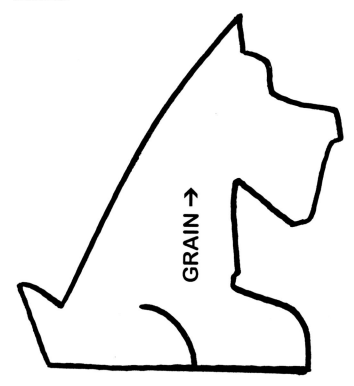

If you can't find the right size wood, you can use 3/4 inch thick wood and make a really thin Gandolf. The grain runs from the base to the head on this thickness as well. I kind of like him thin. There is certainly less wood to remove.

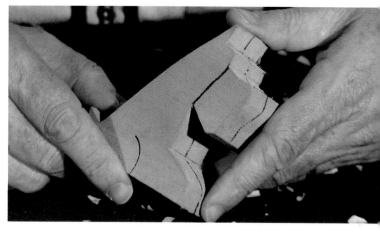

Draw center lines on Gandolf's front. Draw a line to separate the face from the neck. I have painted mine with a blue wash to help the cuts stand out. You don't need to do this to yours.

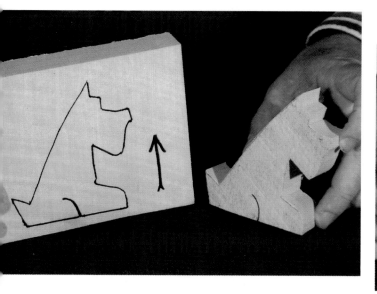

Use carbon paper to transfer Gandolf to a piece of basswood, 1 inch to 1-1/4 inch thick. **The grain runs from the base to the head.** Cut your pattern out with a bandsaw or coping saw. **Be sure to cut the line that defines the hind legs.**

Draw a center line down the back and then make a reference mark 1 inch down from the top of the ears. The reference marks will keep us from rounding the back of the head.

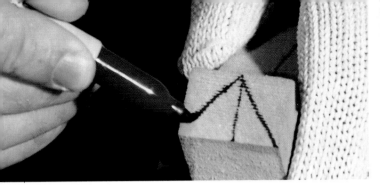

Draw a triangle to define the tail.

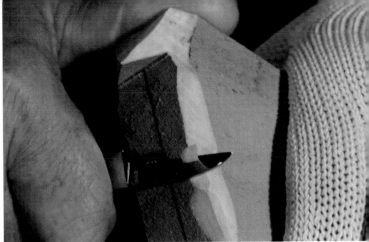

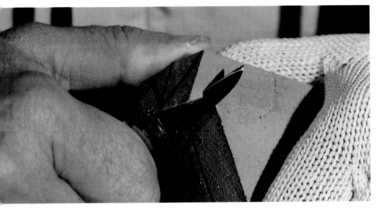

What is wrong with this picture? This picture is a lesson in carving with the grain. My knife is going the wrong direction. **I am carving against the grain!** I don't want to be doing that. I need to be removing wood toward the ears rather than toward the tail. Here is how to test for the direction of the grain. Try a small cut to determine the grain's direction. You should feel very little resistance to the blade when carving with the grain. However, in carving against the grain the blade will "hang up" and it will become harder to pull the blade through the wood. Test the grain and see the difference. After the test you need to round the body toward the center line.

For purpose of illustration, I am not wearing a thumb guard so you can better see the position of my thumb. I strongly suggest you wear a thumb guard with a carving glove.
Shape the tail by removing wood to the triangle.

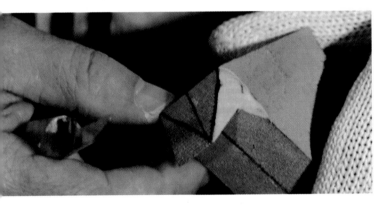

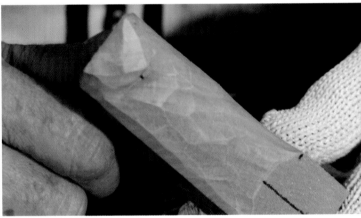

Repeat on the other side. Remember to remove wood with the knife cutting in the direction of the ears. This picture shows the completed rounding.

One side completed.

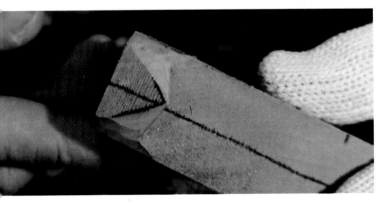

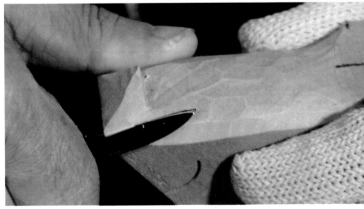

Remove the wood on the other side of the triangle. The tail is shaped.

Remove the saw marks from the top of the tail and do any rounding which needs to be done.

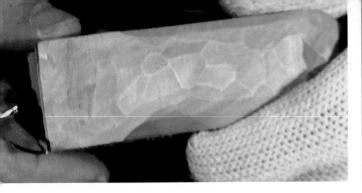

Remove the saw marks from the back of the head. Do not cut into the sides of the head. Remember to remove wood with the knife cutting in the direction of the ears. The saw marks have been removed.

The completed cuts on the top.

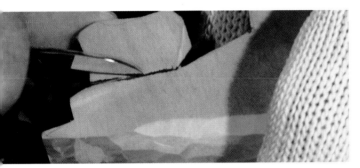

Make a stop cut on the line between the face and neck. I am incising the line. Repeat the other side.

Draw the nose.

Cut back to the stop cut with a pull cut or push cut, which ever works the best for you. I started the cut at the edge of the snout. Repeat the other side.

Cut back from the snout to the line of the nose. The angle of the cut will determine the front feature of the dog. Repeat on the other side. Cut a little on one side, take a look, cut a little more until you are satisfied.

Repeat the process on the top and sides of the snout.

The completed work.

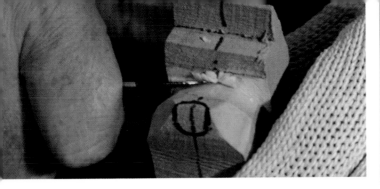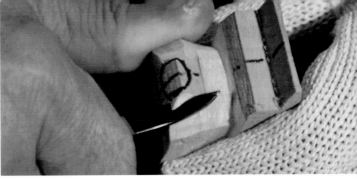

Round the snout to your liking. While you are working, you need to remove the saw marks under the snout.

Cut back to the stop. Exercise the same extra care.

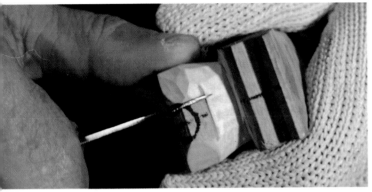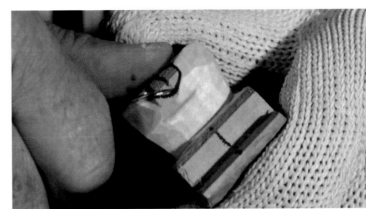

Make a stop cut on each side of the nose.

Round the top and sides of the nose.

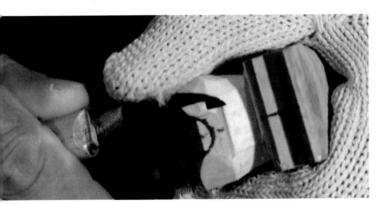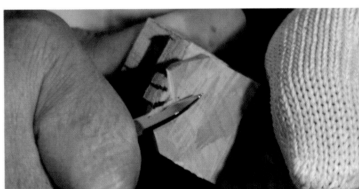

Cut back to the stop. **Make this cut with extra care.** Don't force the knife. You can very easily cut the nose off. Make sure your hand is clear from the path of the knife if it does go through the nose.

Remove the saw marks from the front of the snout and then define the bottom of the nose. This is completed by stop cuts on the lines of the nose and then pull cuts. Exercise care here or you'll be looking for a bottle of glue to reattach the nose.

The wood is removed on one side of the nose.

Round the front of Gandolf to the center line and then clean off any saw marks on the side.

The completed rounding. Repeat the other side.

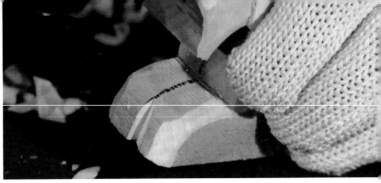

One side of the cut completed.

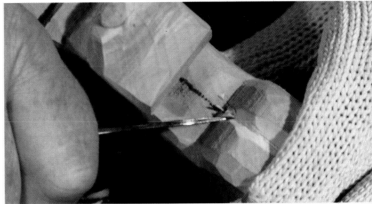

Work your way up the stop cut between the legs until you reach the chest.

What is wrong with this picture? Yes, you are right! I am cutting against the grain again. If I continue with this cut I will break off the front of the foot. My knife should be removing wood toward the body. Give it a test. Don't cut too deep or you could break off the front part of the foot. Ok, back to the project! Round off the front edge of the leg with you knife cutting toward the body. Repeat the other side.

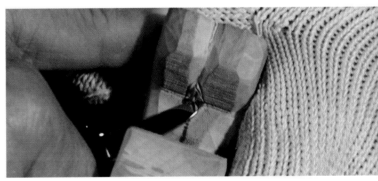

Continue to round the legs into the chest and then do any rounding needed on the top and sides of the legs. You want the legs to have a rounded look.

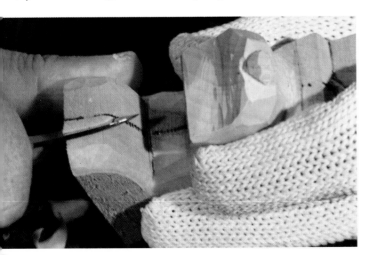

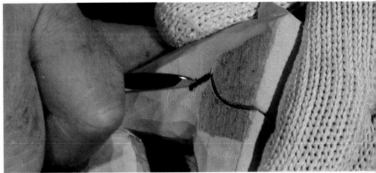

Make a stop cut on the center line between the legs and then cut back to it from both sides.

Turn the dog so it is facing you. Draw a line on the right side of the dog. You can easily see the location of the line (it is black) in the picture. Make a stop cut on the line.

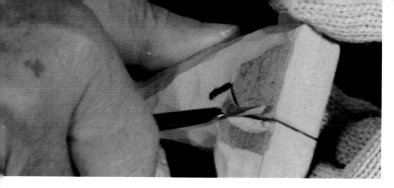

Cut back to the stop cut.

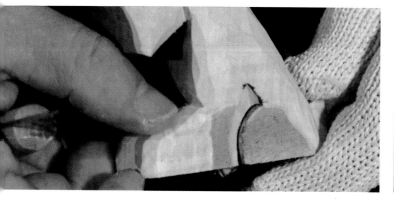

The completed cuts to separate the hind leg from the body.

Turn your attention to the left side of the dog. Make a stop cut where the saw cut stops at the end of the leg. This is a two step cut.

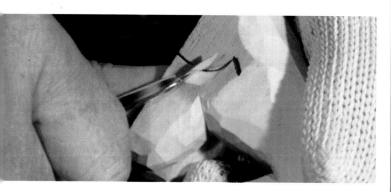

Step 1: Cut away from the stop cut line to the base of the dog. This cut is a good illustration on the advantage of the thumb guard. You can see the knife must exit the wood to complete the cut. The thumb guard can protect the thumb in this situation.

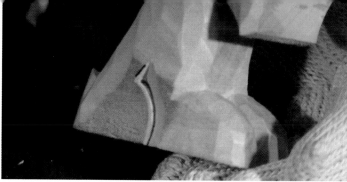

Step 2: Use a thumb push cut to carve back to the stop cut. The leg is done.

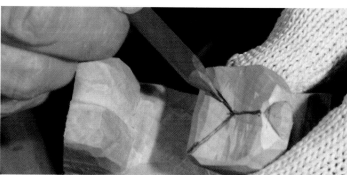

Draw the jowls (jaws).

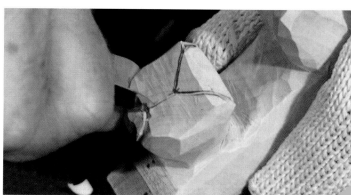

Incise all of the mouth lines.

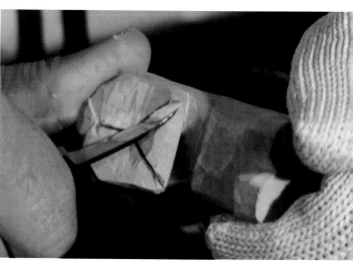

Cut back to the jowls from the mouth area.

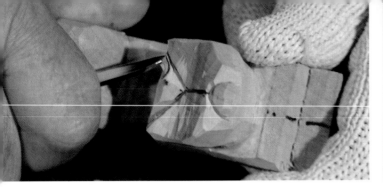

It will take several cuts to work your way around the jowls.

The completed stop cuts on the jowls and the mouth.

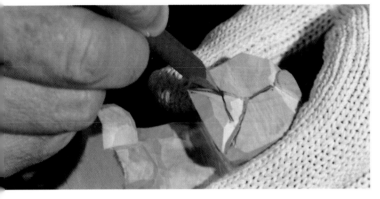

Draw the mouth. I made mine with a smile.

Measure 1 inch from the top of the ear. Repeat the other side.

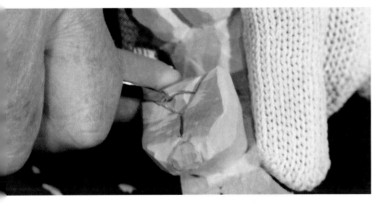

Make a stop cut (incise) the line.

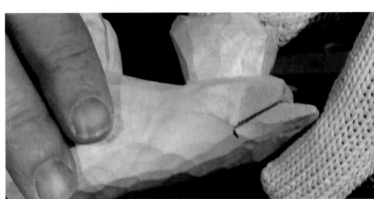

Draw a line from the 1 inch mark to the corner of the ear.

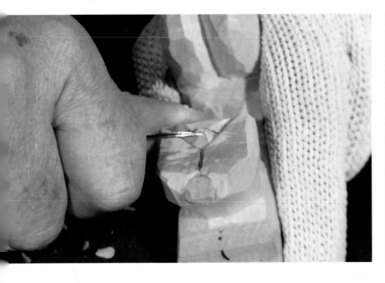

Cut back to the stop cut from the top.

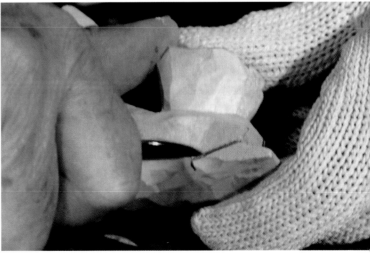

Incise the line.

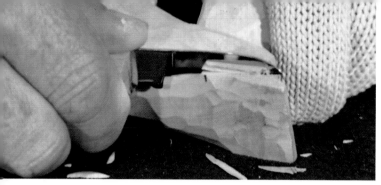

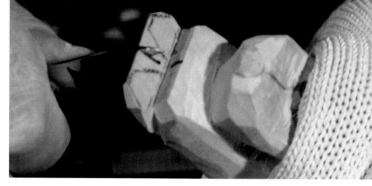

Cut back to the incised line from both directions. You are creating a small valley which will separate the ears from the head.

Make a stop cut down the center line. Don't force the knife.

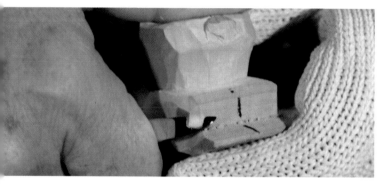

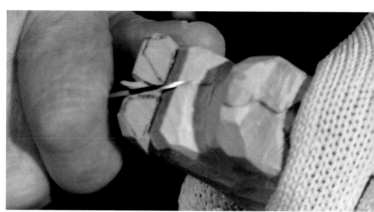

Round the head. I am using a pull cut on this side...

Cut back to the center line from the ear.

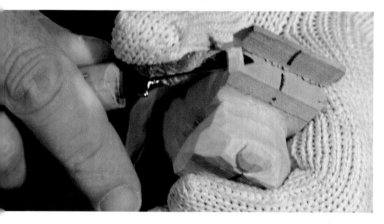

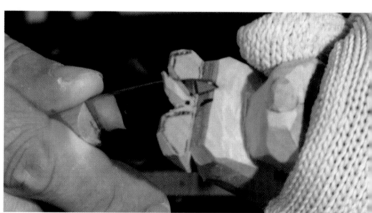

and a push cut for the other side.

Repeat on the other ear.

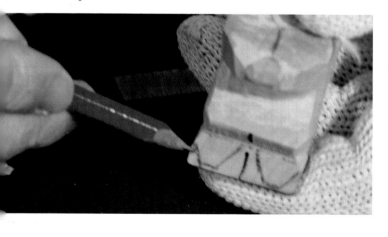

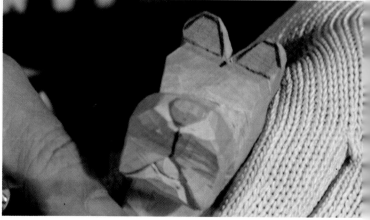

Remove the saw marks from the brow. Mark a center line in the middle of the wood for the ears and then draw the ears.

The completed ears. Nice ears!

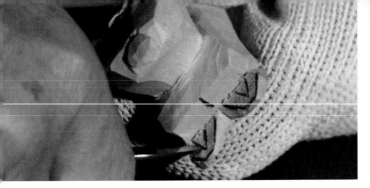

Draw the inside of the ears and incise the lines. You are creating a pyramid cut.

Draw the collar. Don't place it too close to the snout or you might not be able to get your knife under the snout to cut wood away from the collar.

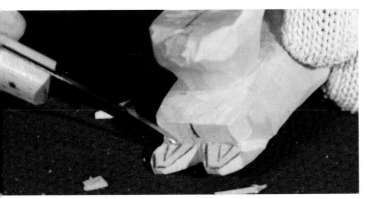

Cut into the ear at the base completing the pyramid cut. The wood should pop out.

Make a stop cut on both lines completely around the collar.

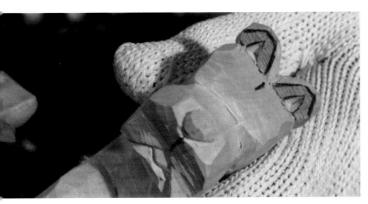

The completed ears.

Cut back to the stop cuts on the collar.

Make a separation between the eyes with a couple of scooping cuts.

The completed collar.

Gandolf thus far.

Cut back to the lines leaving a mound for the eyes.

Draw a center line and then draw the eyes. I am going to use straight lines for the eyes. If you have eye punches, you could use one to make the eyes. **Look ahead to the next couple of steps before proceeding.**

Incise the lines.

The completed eyes. Look over your dog. Do any additional rounding on the body, legs, tail and head. Gandolf is ready for the paint.

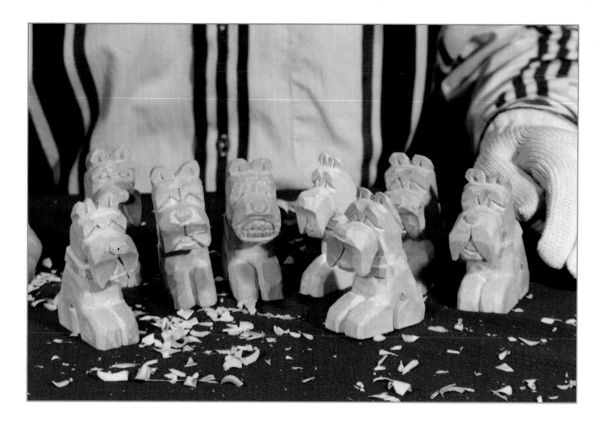

Practice has been the key for me in all of my carvings. I just
keep carving them over and over. Each time the project seems
to get a little easier.

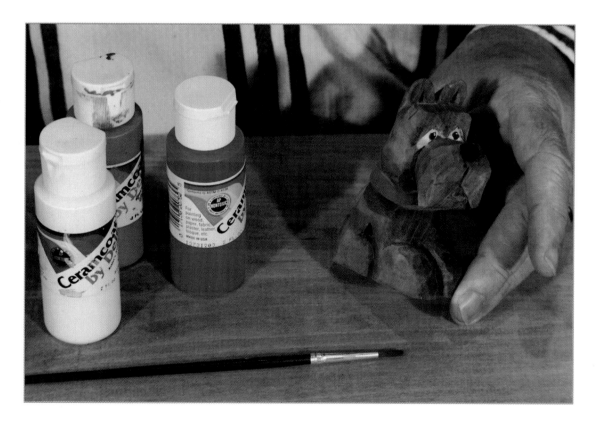

I painted Gandolf using acrylic paints from Ceramcoat® by
Delta. If I want him to have a bright look, I use the paint
straight from the bottle. I prefer to dilute the paint with water
to create a wash. You can create your wash with any ratio of
paint to water.

The Nativity

Joseph

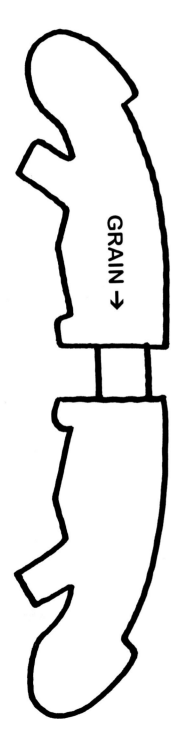

GRAIN →

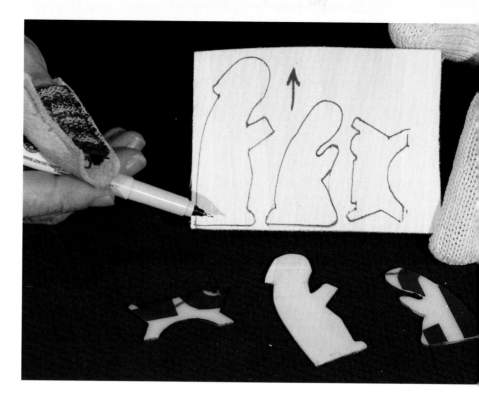

You have two options for using the patterns. **Option One:** You may trace one of each pattern on a 3/4" thick basswood board like I have done. **The grain runs head to toe.** If you find you enjoy carving the nativity, you might want to make a set of patterns you can use over and over again.

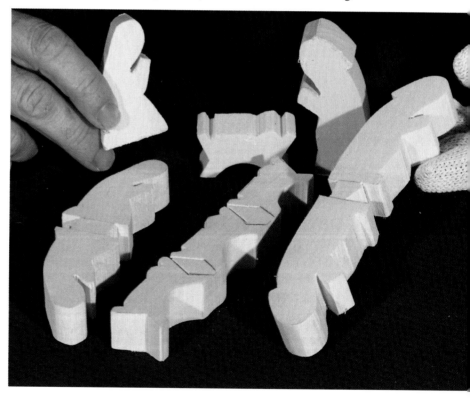

Option 2: You can do what I do when carving smaller projects. I just put two together with some space between them. **The grain runs head to toe.** You can carve on one and then carve on the other for awhile. You will be able to hold onto the figures better. Don't make the part that joins them together too thin or it could break in your hand. You have to choose which method you think will work best for you. I am going to use option 2 for the book.

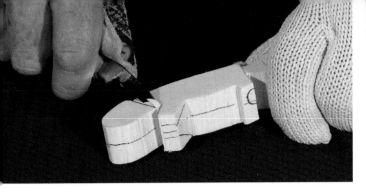

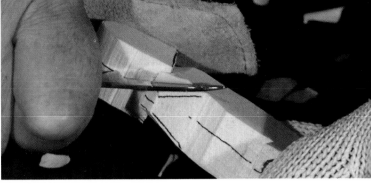

Begin by drawing center lines on the front and back. Draw on the sandal. You can see that it is to one side of the center line. Draw a line to separate the head from the shoulders.

Draw the arms. I leave wood so the hands are approximately 3/8 inch wide. One side is finished and I am working on the other.

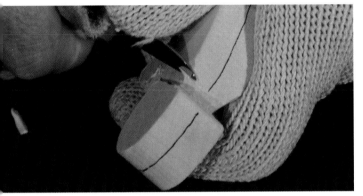

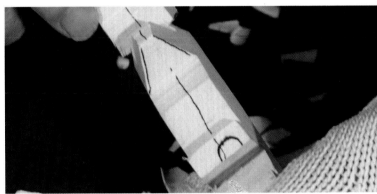

Make a stop cut on the center line that separates the head from the shoulders and then cut back to the line. The next picture shows the completed cut on this step. Repeat on the other side.

The completed shaping of the arms.

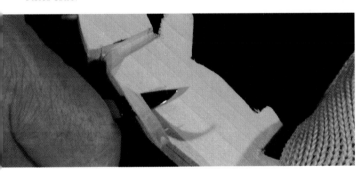

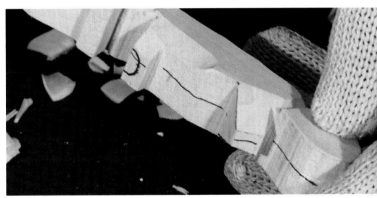

Round the back into the center lines. You need to work from both sides.

Remove some wood from the front side of figure over to the toe. This picture shows the completed work.

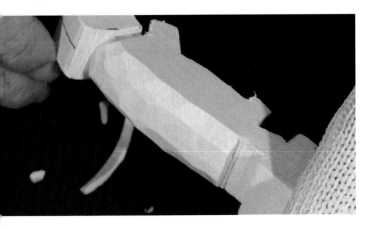

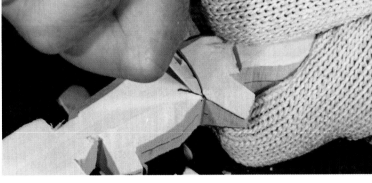

The completed rounding.

Make a mark 1/4 inch long where the lower part of the arm joins the body. Incise the line. Repeat the other side.

45

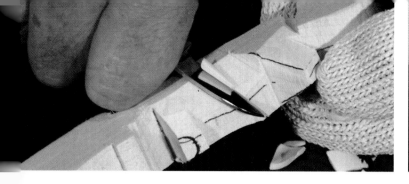

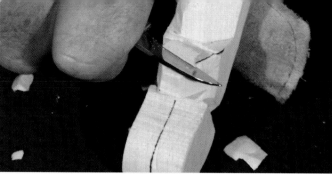

Cut back to the line from the side of the body. You are working to round off the body. Repeat the other side.

Remove the saw marks from under the arms.

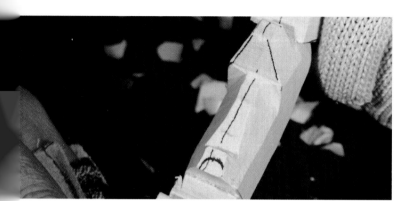

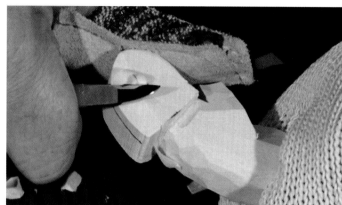

The completed work. I did not round the wood all the way to the center line. This area is the front of the leg and knee. The wood is rounded on both sides of the sandal.

Round the back and top of the head into the center line.

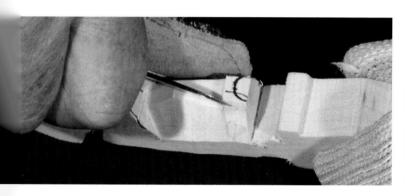

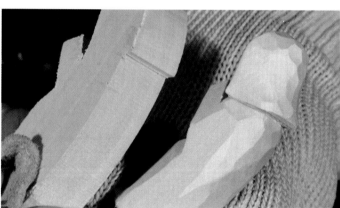

Make stops cuts on the top and each side of the sandal.

The completed rounding. You can compare the progress so far.

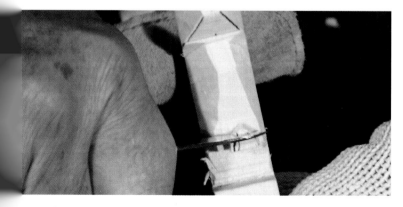

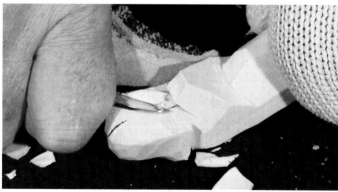

Cut back to the stop cut trimming the wood away from around the sandal. You need to be careful or you will cut off the sandal.

Remove the saw marks from the face. You want to just shave off the saw marks and not dig in.

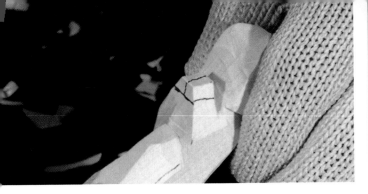

Draw on the hands and the line for the edge of the cloak.

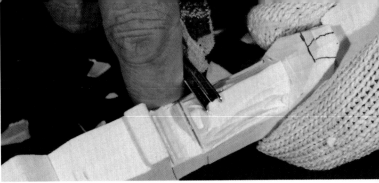

Use the carving tool just above the foot to create a roll in the robe.

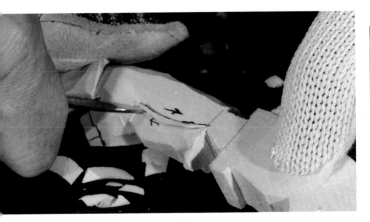

Cut at an angle on the line and then turn the carving and cut in the other direction. This is a line cut as explained in the knife practice session. If you have the angles of the cuts correct, the wood should pop loose. Repeat on the other side.

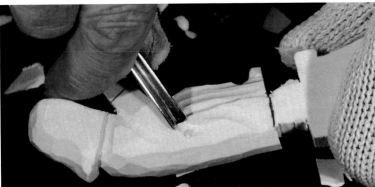

Use the carving tool to create a valley on the top and bottom of the arm where they join the body.

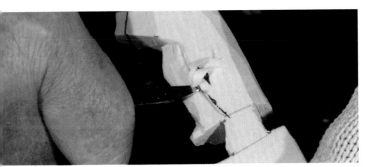

Remove some wood on the robe so it drops back lower than the cloak. Repeat on the other side.

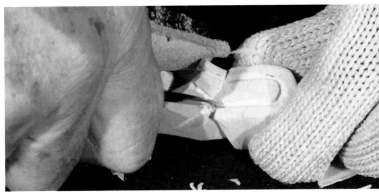

Run your v-tool on the lines for the hands and then use a knife to clean away any wood left by the v-cuts.

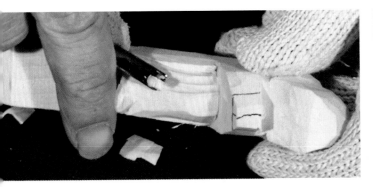

Use a carving tool similar to a 5mm No. 9 gouge or 3/16" veiner to create some wrinkles in the robe. I am using my finger to help me control the gouge; to prevent it from speeding across the carving.

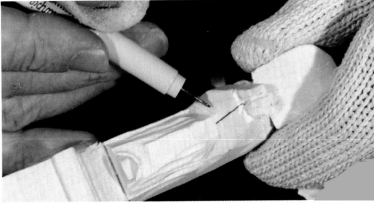

Draw a center line from the bottom of the hands to the robe.

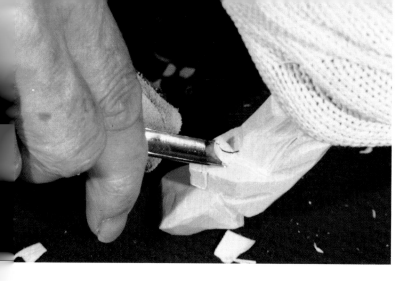

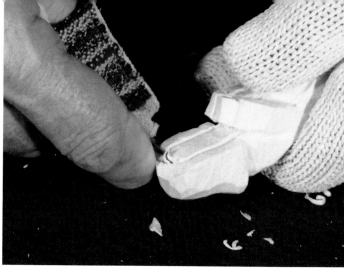

Use a gouge similar to a 5mm No. 9 or 3/8" No. 9 gouge down the line to the robe and then cut away the wood with your knife. The gouge cut will make a nice separation between the arms.

then connect the two side v-cuts to form the face.

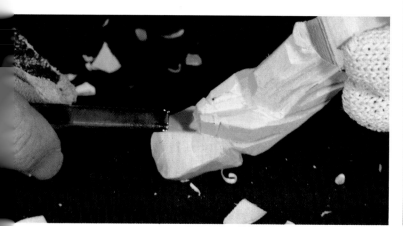

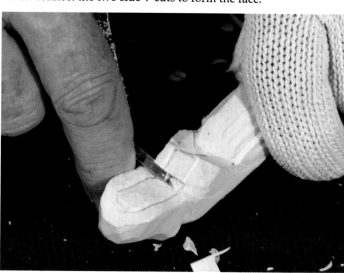

Run a v-tool down the center of the arms. This will really define a separation between the arms.

Run your v-tool between the arms and face to create a neck.

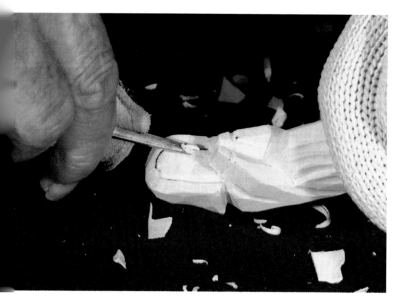

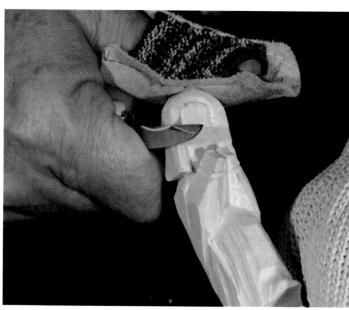

Draw the outline of the face and use a small v-tool on the line. First, v-tool down both sides of the face and...

Do some shaping on the head. It needs to be uniform all around the face.

I am cutting the two Josephs apart.

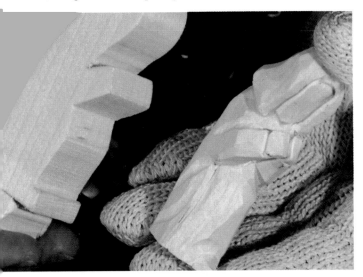

The completed work.

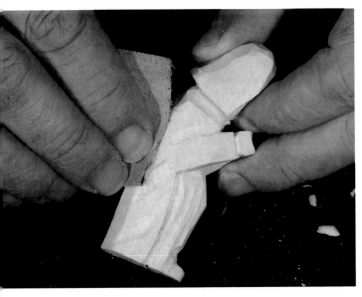

I like to lightly sand the carving to give it a smooth effect. Finish the carving to your liking. You can paint it, stain it or use some kind of clear sealer on it. It is your carving.

Mary

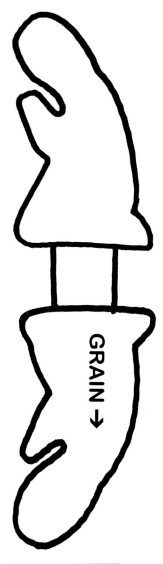

GRAIN →

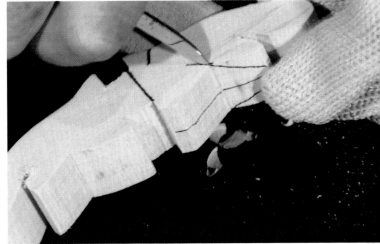

Trace the Mary pattern on a 3/4" thick basswood board using **Option 1** or **Option 2** as explained in the Joseph section. **The grain runs head to toe.** If you use Option 2, you have more wood on which to hold. Mary has some of the same carving steps as Joseph. Draw the center lines on the front and back. Draw the arms. I leave approximately 1/4 inch of wood for the hands. Draw a line 1/4 inch long to extend the arms into the body and then incise the lines. Cut back to the line and then round the body below the arms.

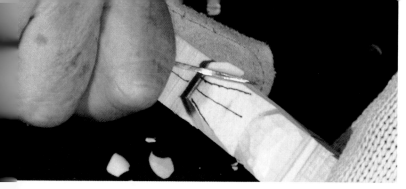

Cut wood away to the line to define each side of the arms.

then from the other to create a valley between the sandal and robe. Repeat on the other side.

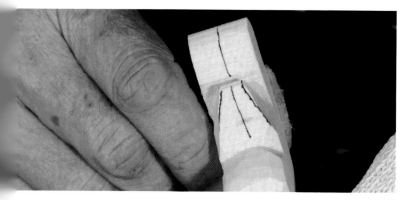

The completed rounding and arms defined.

Incise the center line between the sandals.

Draw a line where the robe and sandals meet. Make a stop cut on the line.

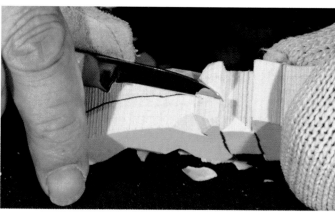

Cut back to that line from both sides to create mounds for the sandals.

Cut back to the stop from one direction and...

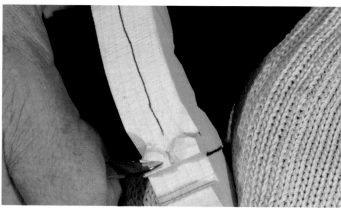

Round the top and sides of each sandal.

50

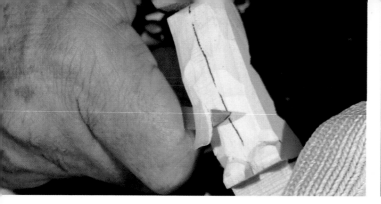

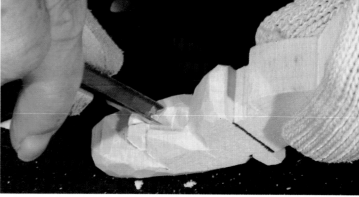

Round Mary's back, and the back and top of her head to the center lines. Clean the saw marks off the front of the face.

Push a v-tool down the valley to create a more defined separation.

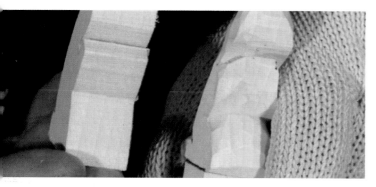

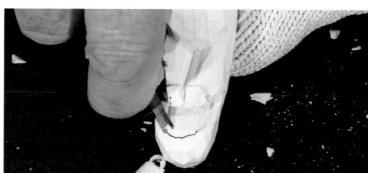

The work so far.

Draw the face, v-tool down the sides of the face, and then connect the two lines at the top to complete the face. After you have v-tooled the lines, do any shaping around the face to make it uniform.

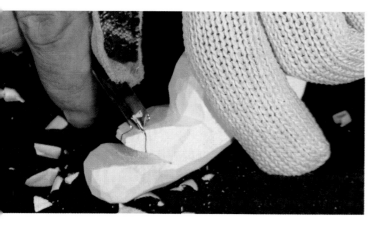

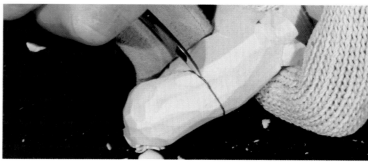

Draw the hands and then v-tool the lines.

Draw a line from the top edge of the arms around Mary. Incise the line. This will define the scarf on Mary's head.

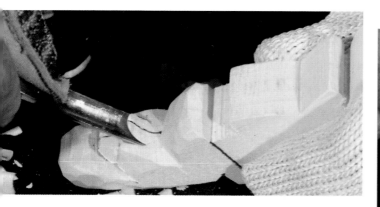

Draw a center line from the hands to the robe and then push a carving tool similar to 5mm No. 9 or a 3/8" No. 9 gouge down the line to create a valley between the arms.

Cut back to the incised line.

Use a tool similar to a 5mm No. 9 gouge on the robe above the sandals to create some wrinkles. Use the same tool to create some wrinkles at the top and bottom of the arms on each side. Look ahead to the last picture to see how these areas would look.

Work your gouge along the front edge of the scarf to create a wrinkle.

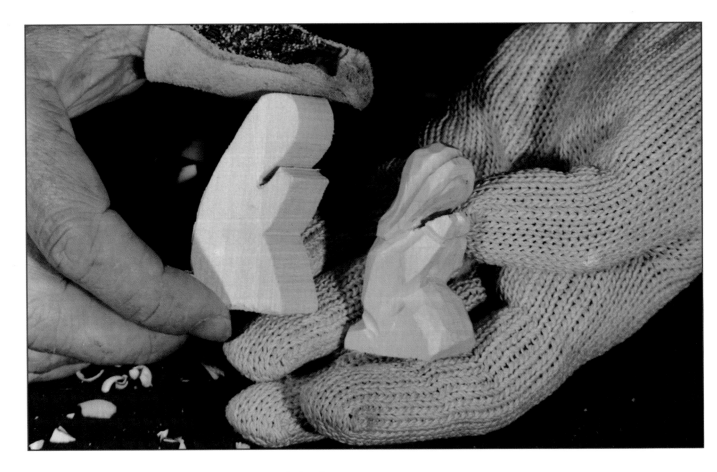

The completed Mary. She is ready to be lightly sanded and painted or stained.

The Baby

GRAIN →

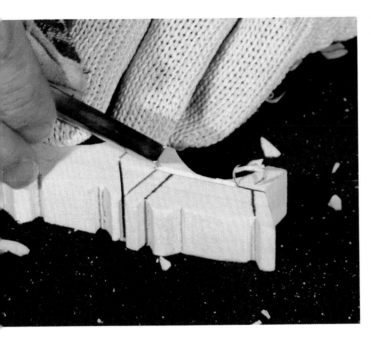

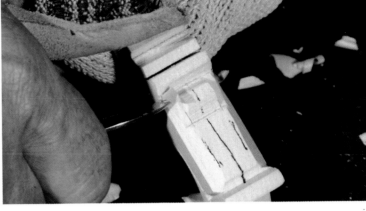

Draw a center line on the baby and then measure over 1/4" inch on each side of the center line and draw a line. These lines will help set the proportions for Jesus' head and the blanket. Carve away the top edge on each side of the manger to the lines.

Trace your pattern onto 3/4" basswood using **Option 1** or **Option 2** as explained in the Joseph section. I have connected three of the mangers together for ease of carving. If you want to keep them together, **do not saw on the dotted line of the pattern**. The three together will give you ample wood on which to hold. Each is connected at the bottom leg. You can refer to the introduction picture where I showed how to carve Joseph. Draw the side board of the manger and then v-tool the bottom line. Repeat the other side.

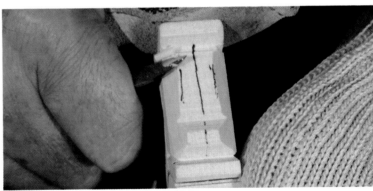

More carving being done on the top edge of the manger.

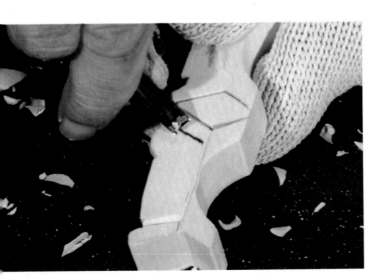

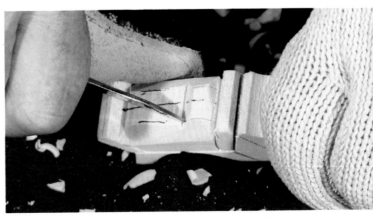

V-tool the two side boards of the manger. Push your tool until it intersects with the bottom line. It might take a cut with a knife to remove the wood where they intersect. Repeat the other side.

Make a stop cut on the line on each side of the head from the blanket to the edge of the manger.

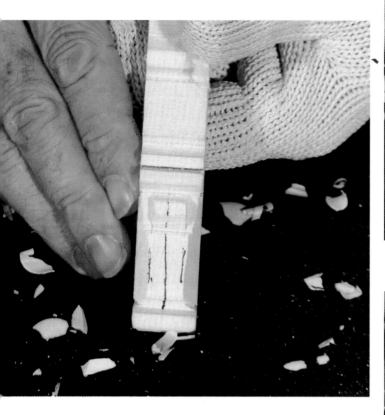

Cut the wood away from the side of the head to a level just below the blanket.

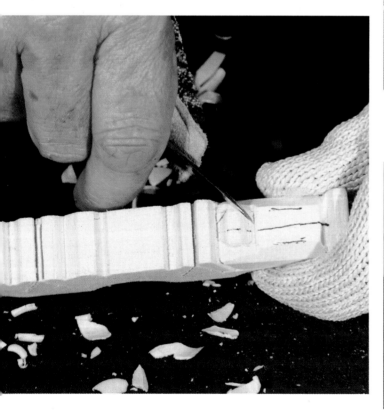

Round the head.

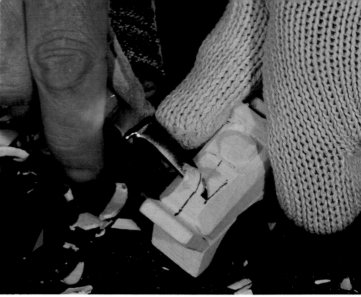

Remove the saw marks from the blanket.

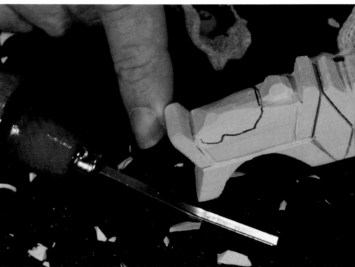

Draw the sides of the blanket and v-tool on the lines. This will create a separation between the blanket and manger.

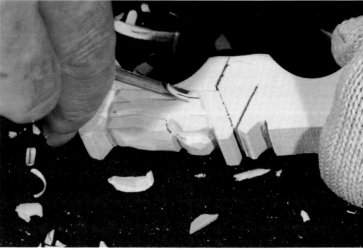

Use a small v-tool to create some boards on the side of the manger.

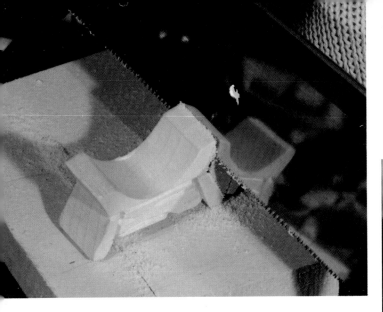

If you have carved with several mangers connected, you can separate your finished one at this time. However, you may wish to carve the other two before cutting them apart.

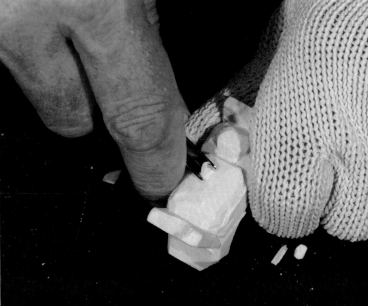

Use a carving tool similar to a 5mm No. 9 gouge to create some wrinkles on the blanket.

Do some rounding on each edge of the manger's legs.

Remove the saw marks from each end.

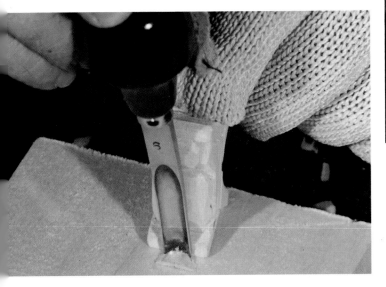

Use a gouge to create a separation at the top of the manger on both ends. I use a block of wood to support the top.

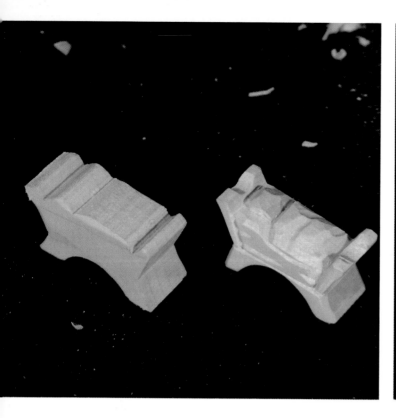

The manger and baby ready to be lightly sanded.

The completed set. I usually create a small base from 1/4 inch wood.

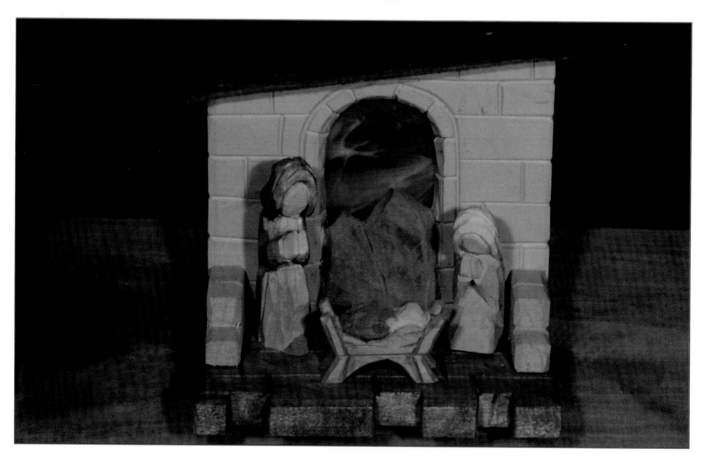

If you wish you can create a wonderful scene, you can construct a stable for you carvings. I used stain glass for the opening to create a sky. The stable and figures are painted with diluted acrylic paints.

56

The Rough Out

The time may come when you want to adventure and carve a rough-out. A rough-out is a figure that is partially machined carved. The rough-out eliminates the hard work of removing a lot of waste wood around the features of the carving. You can purchase rough-outs of all types of animals, Santas, cowboys, bottle stoppers, angels and others.

Tom is going to show you areas where work needs to be done before adding details. In carving a rough-out, these areas are completed before any specific feature such as arms, hands, clothing or other details are carved.

It is not the purpose of this section to show each step to a completed carving. We could do a whole book on that. Our goal is simple: give some of the basis areas to be carved on a rough-out before adding details. It is designed to be a reference for later. The areas are feet, knees, elbows, front and back legs where they join the body, face and hands.

On most rough-outs, Tom removes the base. This allows him to create a base that best fits the finished carving. The first area Tom carves is the feet. Draw the soles and then remove the wood to the lines.

The finished shoe.

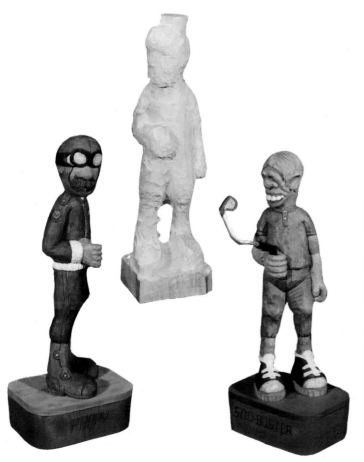

Tom used one style of rough-out to carve two different figures, a pilot and golfer. Therefore, the rough-out can give you the opportunity to let your creativity rule.

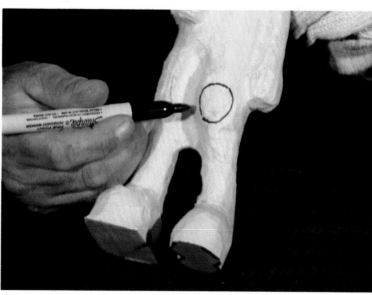

Draw a circle for the position of the front of the knee.

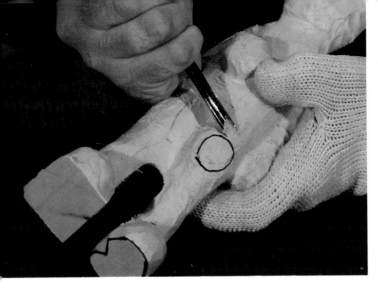

Remove wood completely around the knee.

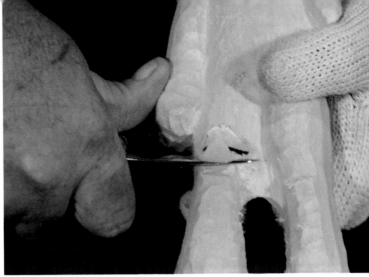

Cut back to the line from both directions. This places the back of the knee in the proper location.

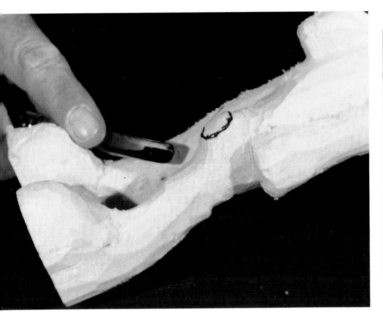

The knee has been set in its proper location.

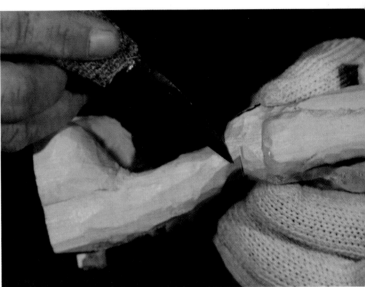

The completed cuts on the back of the knee.

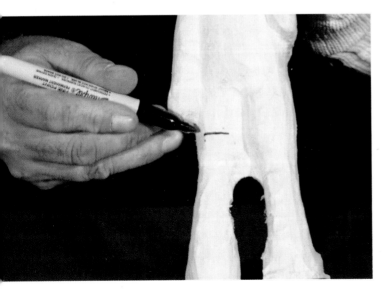

Draw a line in the middle of the back of the knee. This line should be in the middle of the circle on the front.

Repeat this circle and line process on the elbows. Their location has been determined and set.

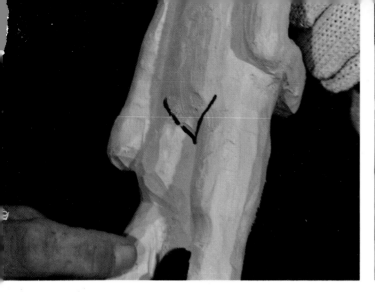

Draw a V where the legs would intersect the rear end.

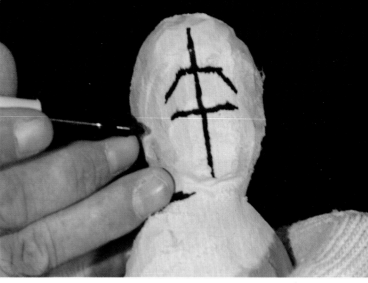

Draw three lines on the face. A center line with a top line for the eyes and a bottom line for the bottom of the nose.

Cut back to the V from each direction and each side.

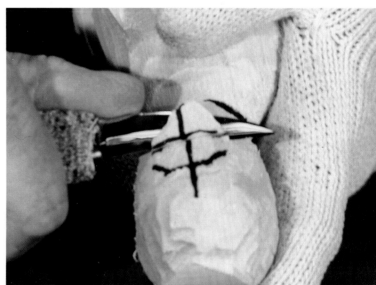

Cut back to the lines to set the divisions of the face.

Repeat the process on the front. You can see how the V and the associated cuts have set the position of the front.

The completed cuts. The face is ready for any detail work.

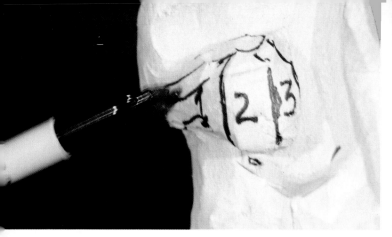

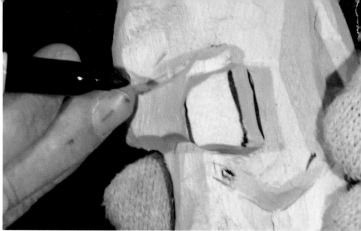

Draw the thumb and then draw the four planes of the hands. No matter what position a hand has, it will have four planes. Of course, some of the planes could be inside a pocket but the hand would still have four planes. In our picture one plane is hidden from the camera.

Reduce the thickness of the hand to create a thumb.

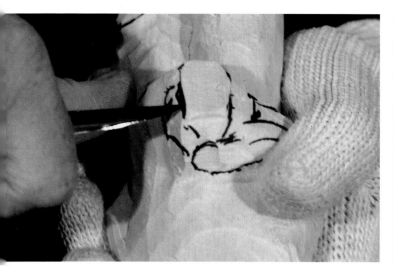

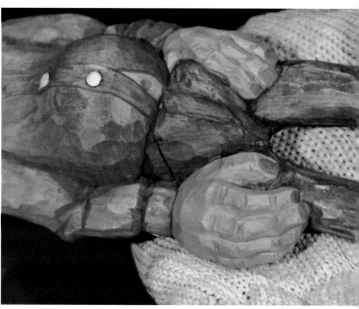

Remove wood from each plane to create the hand.

A completed hand on one of Tom's caricatures. We hope this overview of these major areas will assist you when you carve a rough-out.

Take a Break

The Gallery

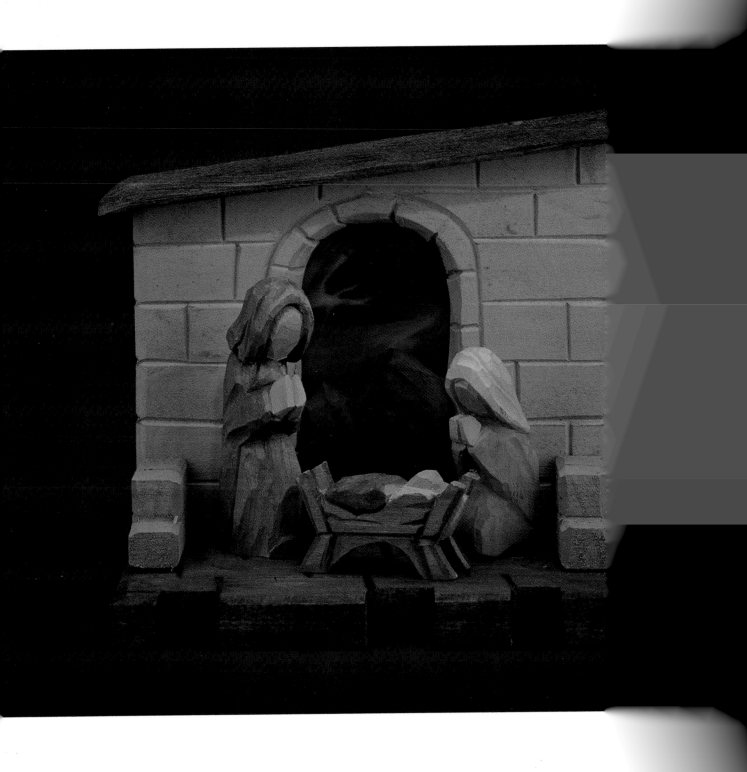

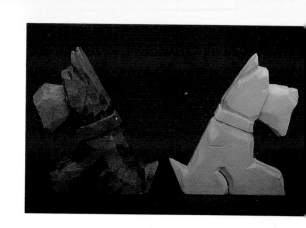
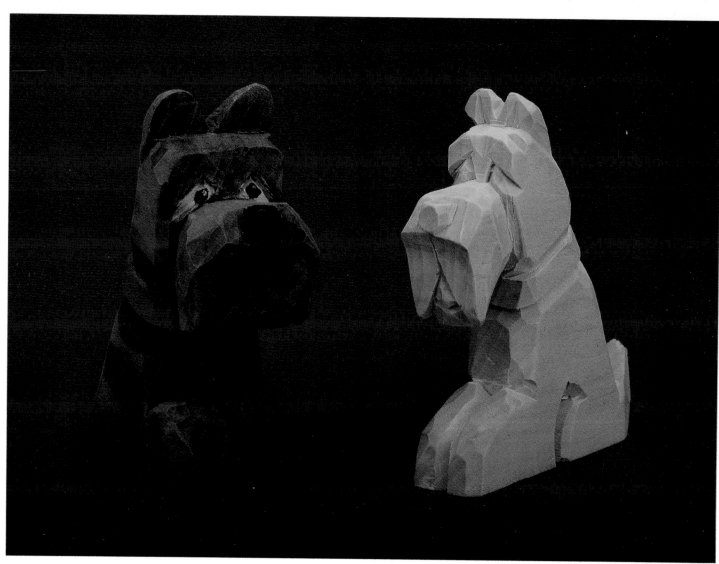
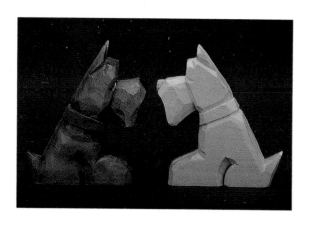
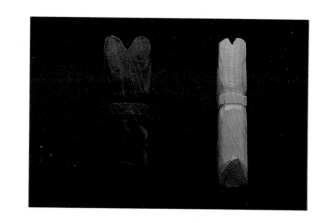

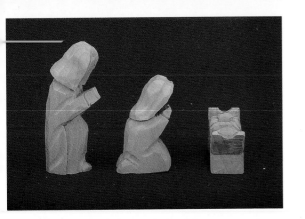

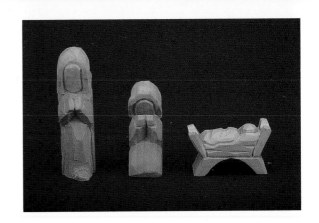

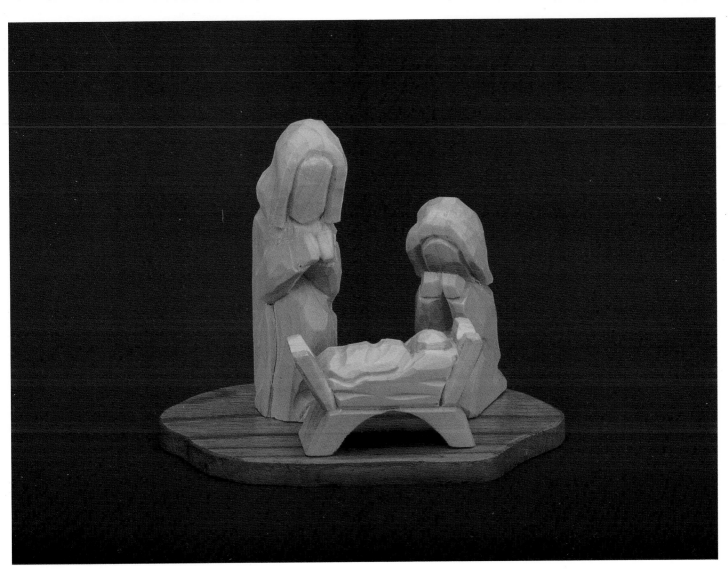

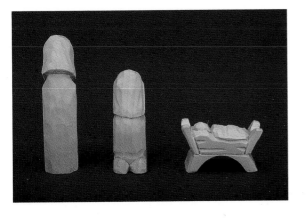

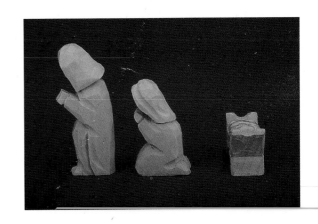

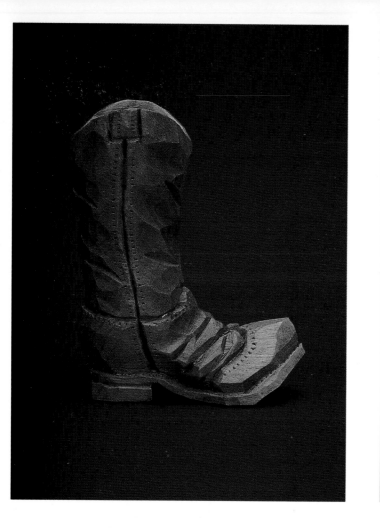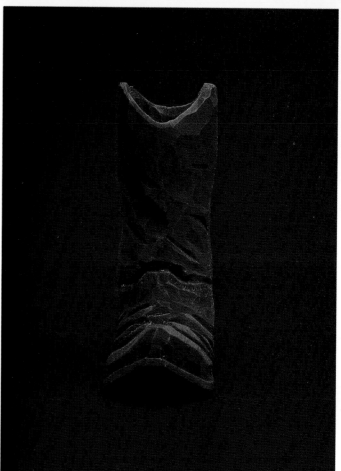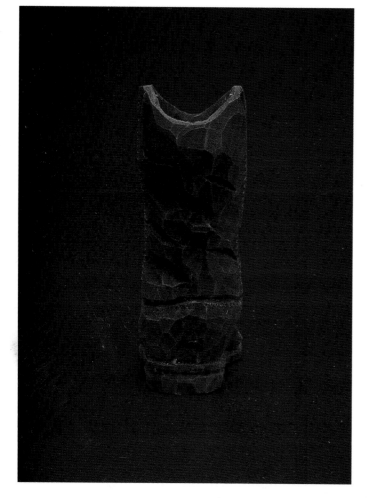